WORLD FILM LOCATIONS HONG KONG

Edited by Linda Chiu-han Lai
and Kimburley Wing-yee Choi

First Published in the UK in 2013 by Intellect Books, The Mill, Parnall Road, Fishponds, Bristol, BS16 3JG, UK

First Published in the USA in 2013 by Intellect Books, The University of Chicago Press, 1427 E. 60th Street, Chicago, IL 60637, USA

Copyright ©2013 Intellect Ltd

Cover photo: *Chungking Express* (1994) © Jet Tone / The Kobal Collection

Copy Editor: Emma Rhys

A Catalogue record for this book is available from the British Library

World Film Locations Series
ISSN: 2045-9009
eISSN: 2045-9017

World Film Locations Hong Kong
ISBN: 978-1-78320-021-4
ePDF ISBN: 978-1-78320-105-1
ePub ISBN: 978-1-78320-106-8

Printed and bound by Bell & Bain Limited, Glasgow

WORLD FILM LOCATIONS
HONG KONG

EDITORS
Linda Chiu-han Lai
and Kimburley Wing-yee Choi

SERIES EDITOR & DESIGN
Gabriel Solomons

CONTRIBUTORS
Evans Chan
Derek Chiu (Chiu Sung–kee)
Chu Kiu-wai
Bryan Wai-ching Chung
Steve Fore
Ho Yue-jin
Rita Hui (Hui Nga-shu)
Mike Ingham
Lam Wai-keung
Anson Hoi-shan Mak
Meaghan Morris
Hector Rodriguez
Wong Ain-ling
Wong Fei-pang
Sugar Xu (Xu Bingji)
Yip Kai-chun

LOCATION PHOTOGRAPHY
Wong Fei-pang
(unless otherwise credited)

LOCATION MAPS
Joel Keightley

PUBLISHED BY
Intellect
The Mill. Parnall Road,
Fishponds. Bristol. BS16 3JG. UK
T: +44 (0) 117 9589910
F: +44 (0) 117 9589911
E: *info@intellectbooks.com*

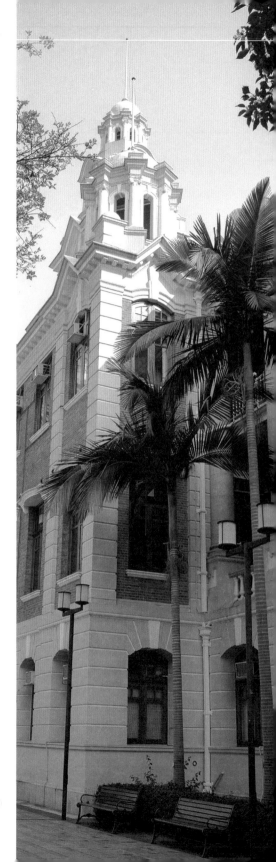

CONTENTS

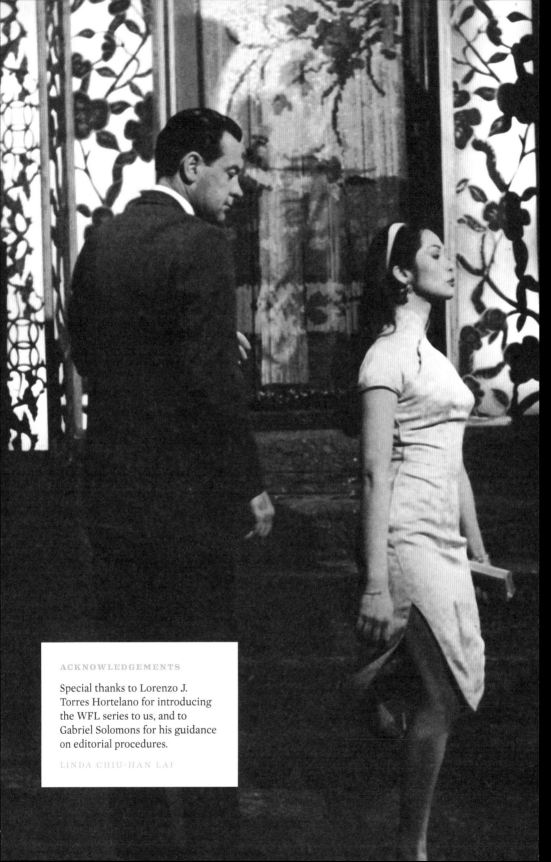

ACKNOWLEDGEMENTS

Special thanks to Lorenzo J. Torres Hortelano for introducing the WFL series to us, and to Gabriel Solomons for his guidance on editorial procedures.

LINDA CHIU-HAN LAI

INTRODUCTION

World Film Locations Hong Kong

THE RAPID DEVELOPMENT of Hong Kong has resulted in extensive demolition of buildings and landscapes of commemorative value. Cinema becomes like a mine rich in mnemonic fragments of lost places, vanished landscapes and material objects. Location shots, each with varied dramatic functions, turn out to have preserved many of the ever-changing and disappearing locations of the city. HK Cinema is a valuable and irreplaceable archive of the city's 'looks' from the past as the city constantly goes through major facelifts.

HK Cinema is intrinsically space-bound. A few places became hot locations for outdoor dramas: some are turned into the iconic equivalence of the city, such as the Victoria Harbour, whereas the drama of many action thrillers and horror films primarily evolve around the physical features of a location. Far more than an ensemble of movie locations, this book delivers a side-view of the history of film production practices in the city (捉姦記/*Caught in the Act* ([Ng Wui (Wu Hui), 1957] and 最佳拍擋/*Aces Go Places* [Eric Tsang, 1982]). Real locations are rare in the 1950s and before. A garden cafe with outdoor seating near the Chinese University of Hong Kong in the New Territories is where peak moments of conflict in romantic comedies erupt and dissipate (玉女添丁/*The Pregnant Maiden* [Chor Yuen, 1968]). Many outdoor scenes in the 1960s and 1970s are in fact the anonymous streets and back alleys of the very neighbourhood of local film companies and studios. The old Kai Tak Airport channels the rage and desire of the colony to other world-class cities (Spotlight #1). Tenement housing, splitting citizens into greedy landlords and the diligent working class of great propriety, contains old-day communal values. As they were gradually replaced by government public housing, social realism recounts crime and fury from one cubicle to the next as much as on long and winding narrow corridors (Spotlight #2). The ghostly and the fiendish of HK horror acquire new under-world pathos entrenched in the material character of home-grown convenient stores, shopping arcades, and lost mansions scrapped under modern high rises and coiling flyovers. As for Wong Kar-wai and Johnnie To's films, multiple protagonists drift and dash through the streets up and down and inside out to the recoils of forgotten livelihoods in a district's periphery, almost recklessly, automatically, or for the sheer pleasure of roaming.

The variety of locations covered in this book includes districts (such as Central, Wanchai, Mongkok), landmarks (such as Jardine House and the Star Ferry), HK-style luminal spaces (such as street stalls, 7-Elevens, back alleys and tenement buildings), passageways and so on. The 38 scene reviews are not just 38 locations. They are the tips of a traumatic spatial history largely submerged and hidden. A possible alternative title of this book could be 'Hong Kong: an Itinerary for Time Travel'.

The ensemble of voices that speak in this book is carefully sorted. We have film scholars, historians, critics, members of the film industry, and film programmers. A few writers are directors from the local industry as well as prominent independent and experimental film-makers. All of them, no doubt, are 100 per cent film buffs. ✤

Linda Chiu-han Lai, Editor

Note: In all pieces, 'Hong Kong' is abbreviated as 'HK' the second time it appears and thereafter. All film titles are appended with non-simplified Chinese characters used in Hong Kong, as opposed to Simplified characters used in Mainland China.

HONG KONG

City of the Imagination

Text by
LINDA CHIU-
HAN LAI
AND STEVE
FORE

IT'S ALMOST CLICHÉ, a banal simplification, too, to say that Hong Kong is crowded.

Tokyo is crowded, but its flyover complexes divide the city into neat zones of dwellings and pockets of street-level identities. New York can be crowded, but only if you are near Times Square or Wall Street on a regular business day. Manhattan to me always affords a leisurely stroll. But Hong Kong...

The sensation of 'crowdedness' in HK is arresting; it compels us to exhaust our vocabulary. I learn, from the many contributors of this volume, that crowdedness is indeed the key and has many names. Traffic jams and crammed public housing needless to say> Crowdedness demands metaphors: crisscrossing strands, labyrinthine passages (龍虎風雲/*City on Fire* [Ringo Lam, 1987]). It has smells and flavours (*The World of Suzie Wong* [Richard Quine, 1960]); it is flared up by speed, exaggerated by the urgency of the moment (*Boarding Gate* [Olivier Assayas, 2007]) and poetized by a very slow stroll (行者/*The Walker* [Tsai Ming-liang, 2012]). Crowdedness is embodied in the exploding desire for a window with a harbour view (Spotlight #6), at least some breathing space (奪命金/*Life without Principle* [Johnnie To, 2011]). There's no crowdedness

without the contrasting presence of hidden avenues of solitary isolation (重慶森林/*Chungking Express* [Wong Kar-wai, 1994]). Crowdedness is about juxtaposition and contrast, the contiguity of the incompatible to the incommensurable: little cubicles self-multiply and pile up, chaos if you zoom in, yet an extraordinary sense of order not quite matched in any other world cities. Crowds mean young people (古惑仔之人在江湖/*Young and Dangerous* [Lau Wai-keung, 1996]). A crowd draws out fear. Crowdedness is when you can't tell gang-boys from ordinary youngsters (去吧！揸fit 人兵團/*Once upon a Time in Triad Society 2* [Cha Chuen-Yee, 1996]). Crowdedness drives people to make space (在浮城的角落唱首歌/*On the Edge of a Floating City, We Sing* [Anson Mak (Mak Hoi-shan), 2012]). Kids on the street prefer to be part of the crowd to flee crowded housing (Spotlight #2). Crowds point to collectivity, to infectious homogenization (生化壽屍/*Bio Zombie* [Wilson YIP (YIP Wai-shun), 1998]). Crowdedness indicates the need to stretch our visual grammar and perceptual consciousness (墮落天使/*Fallen Angels* [Wong Kar-wai, 1995]; 香港製造/*Made in Hong Kong* [Fruit Chan, 1997]). It also demands technical problem solving – how to shoot in a crowded area. Ask directors Ringo Lam and Cha Chuen-yee.

A unique cinematic language evolves to symphonize crowdedness in serial mashed-up scenes. At the turn of a street corner, a main road populated by banks and multinational corporations becomes an old neighbourhood. Collage work brings together crossroads and landmarks from different districts into successive scenes of temporal-spatial continuity. One district is rendered just the same as anothers into one big visual extravaganza of Hong Kong (麥兜菠蘿油王子/*McDull prince a la bun* [Toe Yuen, 2004]). A little girl's runaway excursion becomes a convenient excuse to mash up various crowded spots in the city (小偵探/*Little Detective* [Chan Pei (Chen Pi),

1962]). As chronicled in Wong Kin-yuen's 2000 essay, 'On the Edge of Spaces: *Blade Runner*, *Ghost in the Shell*, and Hong Kong's Cityscape (*Science Fiction Studies*, #80, v27(1)), the Japanese animation team of *Ghost in the Shell* (Oshii Mamoru, 1995) decided to develop a mutated version of HK's built environment as the retro-futurist setting for their story of a cyborg having an identity crisis in the reasonably near future. Influenced by the entropic vision of Los Angeles in *Blade Runner* (Ridley Scott, 1982) and the post-apocalyptic Tokyo of *Akira* (Otomo Katsuhiro, 1988), they were intrigued by the tension in HK between ultra-modern high-rise structures and older buildings representing diverse cultures and times. In a scene in *Ghost*, the now-dilapidated Streamline Moderne low-rise residential buildings are still hanging on in some Hong Kong Island neighbourhoods such as those along Queen's Road East in Wanchai, as well as the start of Ladder Street. The latter dated from the 1840s, off Queen's Road Central, which was the first built thoroughfare by the harbour front. This architectural variety in turn suggests the film's theme of unstable, fluid, sentient identity in a technologically advanced society. Oh, and this pastiche of HK has canals in addition to a harbour.

At the extreme opposite end of crowdedness, we have vacant spaces pending for their next round of usage, turned into the Film Service Office's real estate portfolio since 1998. They are disused

> **In a key scene in *Autumn Moon*, a Japanese tourist is fishing in the harbour, only to be warned by a passing local teenaged girl that available fish are both tiny and contaminated by pollution.**

office mansions, spatial tokens of HK's former colonial administration. During their lingering presence without a designated purpose, the practical HK government invited film-makers to use them for inexpensive rented sets. (Spotlight #4)

Due to the size of the book, one type of important location has to be left out. In the 1960s, as a result of a strong studio system emerging, HK films were mainly filmed inside the studio. On-location shooting, often used for narrative transitions, occurred in places nearby the film companies. This was the case for Daguan Motion Pictures, MP & GI, Shaw Brothers Studio, Yung Hwa and Golden Harvest, which all happened to have set up their studios in Kowloon near the old airport and in Diamond Hill, now a residential area (打蛇/*Lost Souls* [Mou Tun-fei, 1980]). Many Cantonese classics in the 1960s, such as *Eternal Regret* (孽海遺恨, Chor Yuen, 1962) and *Country Boy Goes to Town* (看牛仔出城, Chan Cheuk-sang, 1965), were filmed in Diamond Hill.

As the writings by all contributors finally came in, we couldn't help noticing some significant repetition. Victoria Harbour and the Star Ferry pop up many times, each time articulating a facet of our subdued sentiments as insider-residents of this crowded city. Victoria Harbour is concrete existence of a fiendish kind. Its charm is also nightmare. It has long been the single most famous geographic icon of HK. Unfortunately, it has not always received the respect it deserves. Over the last century, recurrent land reclamation projects have reduced the harbour's width from 2,300 metres to the current 910 metres. Pedestrian access to a harbour-front view is difficult on the Kowloon side and all but impossible on Hong Kong Island. In a key scene in *Autumn Moon* (秋月, Clara Law, 1992), a Japanese tourist (Masatoshi Nagase) is fishing in the harbour, only to be warned by a passing local teenaged girl that available fish are both tiny and contaminated by pollution. In the background is the glamorous skyline of Central and Wanchai, and the film provides a pretty genuine tourist's view – as they frequently are, the distant skyscrapers here are shrouded in thick smog. Victoria is more than a harbour. It marks family tragedies, world financial crises, and the research subject of diligent ethnographers (Spotlight #6, *Life without Principle*, 唱盤上的單行道/*One-way Street on a Turntable* [Anson Mak (Mak Hoi-shan), 2007]).

There must be many more untold stories. ✢

HERE, THERE AND IN-BETWEEN

Transitional Space in Hong Kong Movies

Text by
KIMBURLEY
WING-YEE
CHOI

KAI TAK AIRPORT, the international airport of Hong Kong from 1925 to 1998, was expanded several times between the 1950s and 1970s in response to growth in commercial air travel. *Air Hostess*/空中小姐 (Evan Yang, 1959), which opens with Air Hostess Kepin (Grace Chang, aka Ge Lan) singing the song 'I Fly Up to the Blue Sky' (music: Yao Ming; lyrics: Evan Yang, 1959), may reflect the appeal of air travel to business travellers back then. One of HK's earliest colour movies, *Air Hostess* portrays the professional lives of flight attendants: they are modern, elegant and unfettered, yet they abide by the strict rules of their job. Crime is a crucial dramatic device – smugglers allure Kepin and Xinjuan (Julie Yeh Feng) to bring jewellery into Singapore. Hence the film's portrayal of airports as transitional zones where modernity, not traditional values, reigns supreme is ultimately also a cautionary tale supporting the presence

of strict rules in a somewhat lawless frontier. As transitional spaces, airports mark narrative changes. Characters are situated in between the legitimate and the illegitimate.

The airport also provides the characters with the opportunities to change. In *My Intimate Partner*/難兄難弟 (Chun Kim, 1960), buddies Ng Jui-choi (Patrick Tse Yin) and Chow Yat-ching (Wu Fung) are both in love with Ying (Nam Hung), who simply treats them as friends as she is engaged to someone in South East Asia. In a key scene set in the airport, Ying receives news about the death of her fiancé from Tsui-lam (Kong Suet), his sister. This airport scene marks Ying's new beginning: she may now freely start her romantic relation with Yat-ching, and Jui-choi soon falls in love with the newly arrived Tsui-lam, thus the problematic love triangle gets resolved into two legitimate romance stories.

In *A Gimmicky World*/綽頭世界 (Mok Hong-sze, 1963), the airport again marks a new beginning in life, this time for the female protagonist Wang Lan (Patricia Lam Fung). Wang is persuaded by evildoer Zeng Hong (Lee Pang-fei) and her adoptive mother to approach a rich young man from the States to cheat his money through gambling. In the film's finale, Wang races off to the airport, determined to leave HK and relocate to the States with her new boyfriend. Devoid of pronounced historical and personal traditions, the airport here functions as a site where people can abandon their erstwhile identities and even their families (such as an unscrupulous adoptive mother) in favour of a new life.

The use of transitional space in HK movies

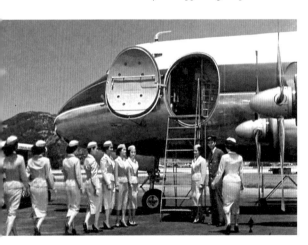

belongs to the world of law enforcement and that of lawbreakers and who, therefore, forfeits a clearly demarcated identity.

In 1998, Chek Lap Kok replaced Kai Tak as Hong Kong International Airport, and the construction of Stonecutters Bridge was part of the new airport project. The unfinished Stonecutters Bridge suggests no new life or transformation, but reminds audiences that characters in the millennium have no way out except death. *Overheard*/竊聽風雲 (Felix Chong and Alan Mak, 2009) is about people's distrust of law enforcement and the legal system in the context of capitalist finance. Two officers, Yeung (Louis Koo) and Lam (Daniel Wu), overhear that the stock price of a firm involving commercial crimes will soar when the market opens the following day. They delete the 'insider trading' portion of the recording and quickly purchase substantial shares of the stock in question with a big, tenuous loan. Their acts result in the murders of both Yeung's family and Lam himself. A year later, police collect records incriminating the head of the firm for arrest. Under police escort, Yeung drives himself and the firm's 'Boss' off the unfinished Stonecutters Bridge into the harbour; meanwhile, the police supervisor on location deliberately turns off his walkie-talkie connection to allow Yeung's extrajudicial killing to finish. Situated beyond HK's structured and hierarchical political–legal–economic system, the unfinished bridge as transitional space provides shelter for Yeung and his supervisor to challenge accepted rules and the general ethos of judicial administration. But rather than bring the protagonists a new life, the unfinished bridge to the airport extricates them from a vicious spiral into the depths of crime.

The airport in HK Cinema has been a marker of opposing forces and contrasting options. Back in the 1950s and 1960s, the binary was more obvious: a character stays to struggle versus takes off for new freedom, or a character stays to acknowledge responsibilities versus takes off to escape. In recent examples, the airport figures more strongly as the chase-passage for traumatic exits as existential situations become increasingly complex, and the black-versus-white measure of law and morality no longer stands. The airport is no simple transitional space for change and transformation, but a ground of the in-between on which strands of changing values of global financial capitalism spin off, if not entangled. ✠

since the 1980s seems less optimistic. In *City on Fire*/龍虎風雲 (Ringo Lam, 1987), undercover cop Ko Chow (Chow Yun-fat) is caught between loyalty toward his friends and his duties as a police officer. Adding to his struggles is his relationship with his nightclub girlfriend Hung (Carrie Ng), whom he wishes to marry after quitting the force. In a key scene, Ko rushes to the Kai Tak Airport to ask Hung, the impatient bride-to-be, not to abandon him and HK for a married man. But right after his proposal, he is apprehended by the police for his previous gun sales to a gang of thieves. The airport scene indicates the crossroads these two individuals have reached: they need to decide whether to maintain the *status quo* (i.e. Ko continuing to be an undercover cop and Hung keeping her rocky relations with him) or to make substantial life-trajectory changes (i.e. Ko quitting the force or Hung leaving him for good). In the film, Hung's actions undercut Ko's desire to resign from the force, as he decides to infiltrate the gang of thieves and to carry on being a marginal person – someone who

> **Back in the 1950s and 1960s, the binary was more obvious: a character stays to struggle versus takes off for new freedom, or a character stays to acknowledge responsibilities versus takes off to escape.**

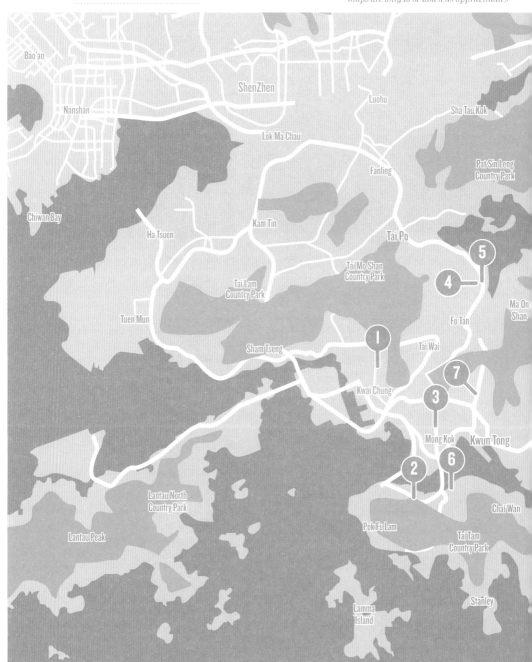

HONG KONG LOCATIONS
SCENES 1-7

Sai Kung

Kai Sai Chau

Clear
Water Bay

CAUGHT IN THE ACT (1957)

*Wader Motion Picture & Development Co. Ltd,
Castle Peak Road 6.5 m, Kwai Chung*

SCREENWRITER YEUNG (CHEUNG YING) is working on a new story,
'Murdering My Wife'. Ever since a fortune teller predicts his wife will be
unfaithful, many everyday details seem to suggest his wife could actually
be planning on murdering him. Feeling suspicious and insecure staying
home, he slips out to Wader film studio. Between home and office is a twelve-
second pan-shot, an exterior survey of Wader Motion Picture & Development,
the company that shot *Caught in the Act*. Supposed to be a brief narrative
transition, the segment is more an excuse to show off the actual film studio.
Thanks to the digression, we get to see the physical components of the
80,000-square-foot Wader: a bungalow apparently the reception office, one
multi-storey office building, and a complex of two studios, one bigger than the
other. In the open space enclosed by the buildings were half-done furniture
and construction material. Wader had top camera facilities with its own
cinematographer, set designer, lighting and recording artists – suitable for
full-package rental to companies without a studio. Wader's investor was Ho
Kai-wing, helm of Kong Ngee, one of the three major (HK-made) Cantonese
film distributors in Singapore. Wader ensured a continuous supply of films
for the Kong Ngee network, at a time when movie-going brought great
fortunes to distributors in Singapore. Where Wader stood is now a park above
public housing in Kwai Chung. In the 1960s, an early phase of public housing
development, the vicinity of Wader was a favourite spot for action scenes in
many Cantonese films. ➥*Linda Chiu-han Lai*

Photo © Wong Fei-pang

Directed by Ng Wui (Wu Hui)
Scene description: Screenwriter Yeung goes to Wader film studio to discuss a screenplay
Timecode for scene: 0:23:52 – 0:24:08

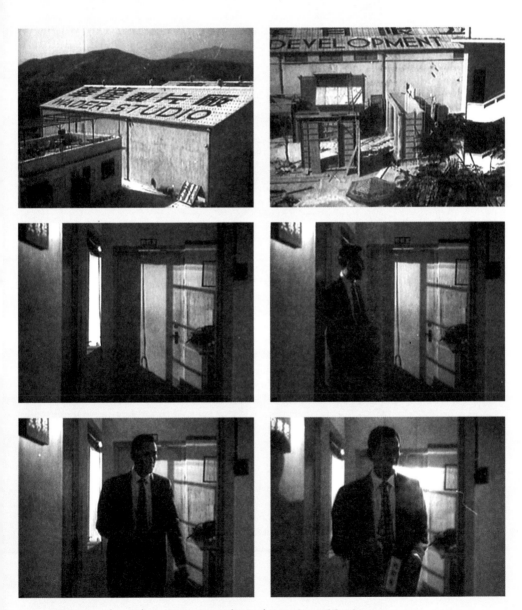

Images © 1957 Tak Ngai (Dak Aau) Film Company, Wader (Wa Daat) Motion Picture & Development

OUR DREAM CAR (1959)

Star Ferry Pier parking lot, Central

GRACE CHANG AND CHANG YANG played a young middle-class couple, the husband a junior engineer and the wife in the fashion business. Every day after work, they would meet at the Edinburgh Place Ferry Pier, more commonly referred to as the Star Ferry Pier. The first time we are introduced to this scene, the camera follows Grace Chang as she walks elegantly across the pier's vast parking lot. As the clock tower chimes five, she sits down on a bench by the waterfront. Life is modest yet sweet ... until a dream car comes along. The second time we are brought back here, the couple has already bought their dream car. The loan they take out to pay for it has sparked a string of marital disputes. Towards the end of the film, we return again to this symbolic place. In the end, our protagonists have sold their car and rekindled their love for each other. These three scenes mark the twists and turns of the film's dramatic structure. The third generation Star Ferry Pier, with its clock tower, was built in 1957 at the height of the Modern Movement. *Our Dream Car*, a delightful comedy filmed in the same period, is a sensitive portrayal of a city undergoing a vibrant evolution. Modernity is the issue. The pier was retired from service on 11 November 2006, when it was demolished to make way for a reclamation project. This marked the end of an era, and aroused great controversy and popular protests. •➔ *Wong Ain-ling*

Photo © Wong Fei-pang

Directed by Evan Yang

Scene description: Grace Chang waits for her husband Chang Yang at the Star Ferry Pier parking lot after work
Timecode for scene: 0:2:18 – 0:3:53

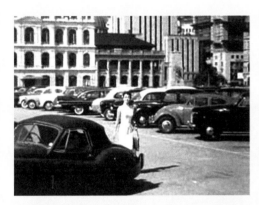
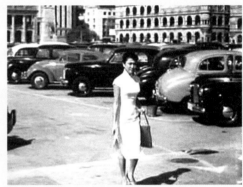
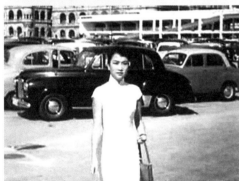
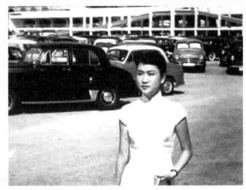

LITTLE DETECTIVE (1962)

Prince Edward Road at Waterloo Road, Nathan Road (Mongkok), Homantin, Yaumati, Star Ferry (Tsimshatsui)

EXTENSIVE USE OF REAL LOCATION was uncommon in local film-making until the late 1960s. But trial attempts were not lacking in the 1960s. Film-makers inserted glimpses of streets in the company's neighbourhood for temporal-spatial transitions. To contemporary viewers, they are precious 'documents' of a lost landscape. In *Little Detective*, an atypically prolonged outdoor sequence of three and a half-minutes marks the story's turning point. Siu-lan, little daughter of reputable Inspector Yiu Kong (Ng Cho-fan), desires to follow daddy's footsteps but can't wait. One day, she begs a father's subordinate to teach her how to use a gun and accidentally puts a bullet into his hip. Terrified by the thought of being jailed, she flees home and roams through the busy streets of Kowloon. The camera waits on Prince Edward Road at Waterloo Road, observing St. Teresa's Church, with Maryknoll Convent's College on the right and the Lion Rock behind as Siu-lan enters the shot. Next, Siu-lan pushes through the crowd in front of a cinema showing a film starring Spencer Tracy. A local bakery where she begs for bread... Nathan Road – HK & Shanghai Bank's Kowloon head-quarters... King's Park, Homantin... A corner of Austin Road... Street stalls in Yaumati. Finally, we see Siu-lan wandering outside the Star Ferry in Tsimshatsui, which marks the edge of her world. With no money, she cannot cross the harbour to Hong Kong Island, which fills the backdrop of the shot. Petrina Fung (aka Fung Bo-bo) was seven when she played Siu-lan. In 1961 alone, she appeared in over 30 films. **→Linda Chiu-han Lai**

Photos © Wong Fei-pang

Directed by Chor Yuen
Scene description: Lai-fong is on guard during Lai-sheung and Chi-wai's date
Timecode for scene: 0:1:14 – 0:2:15

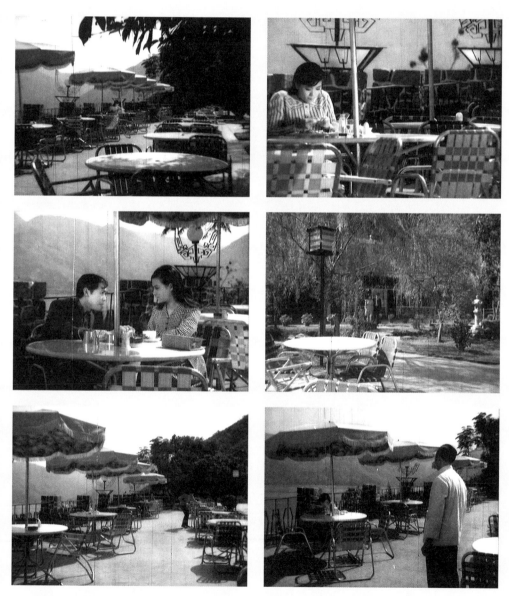

Images © 1968 Hou Hou

YOUNG PEOPLE (1972)

LOCATION *Chung Chi College Library and sports field,*
Chinese University of Hong Kong

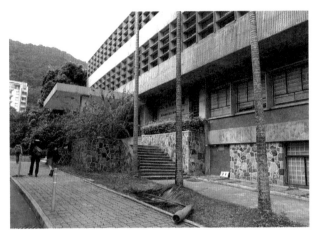

YOUNG PEOPLE reflects one attempt by the director Chang Cheh to incorporate popular music and modern dance into his martial arts films. It tells the story of young university students engaging themselves in various extra-curricular activities, such as music, dance, basketball games, martial art, and kart racing. The three male characters Hung Wai (David Chiang, a drummer), Lam Tat (Ti Lung, a basketball team leader), and Ho Tai (Chen Kuan-Tai, a martial arts champion) compete, collaborate, and finally develop a strong brotherhood that is common in Chang's films. Chang shot the film at the Chinese University of Hong Kong's Chung Chi College, itself nested in Shatin's rural and spacious countryside. The university, a collection of former colleges in mainland China, would use Chinese as the main language for instruction, in contrast with the University of Hong Kong, an English-speaking university with pronounced colonial sentiments. Martial arts traditions naturally continued at the Chinese University of Hong Kong. Traditional martial arts films often hide their great masters from the main stage. They are shabby beggars, chubby Buddhist monks, or skinny Taoist priests, and never the masculine heroes. The film *Young People* observes this tradition. In the parking lot's gang-fight scene, Lam Tat and Ho Tai –both wearing tight-fitting sportswear –engage in a lengthy combat. Hung Wai, the real master, masquerades as the dandyish drummer boy and defeats them in a split second. Perhaps audiences will glean wisdom from Chiang's obsessive and mindful drum-roll practices at the beginning and end of the film.

↦Bryan Wai-ching Chung

Photos © Bryan Chung

Directed by Chang Cheh
Scene description: Lam Tat bullies music club members
Timecode for scene: 0:12:38 – 0:15:23

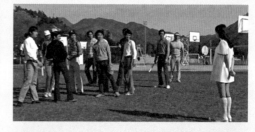

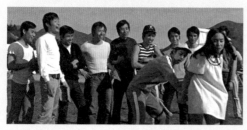
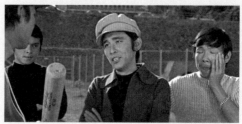

GAME OF DEATH (1978)

LOCATION *Red Pepper Restaurant, 7 Lan Fong Road, Causeway Bay*

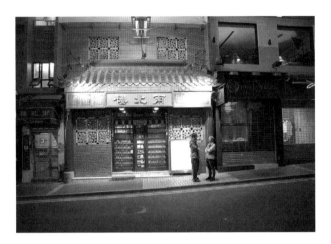

THE RED PEPPER RESTAURANT is the centre-stage in *Game of Death*, especially for the final twenty minutes, the only portion of the film when we get to see the real Bruce Lee (who died in 1973) fighting various actors from unused footage of past works. The rest of the film uses a look-alike Bruce-Lee surrogate and shadowy camera work. Billy Lo, an action-movie star (Bruce Lee), uproots a gang that has attempted his life after he refuses to have his career 'managed' by them. He breaks into Red Pepper, their secret base, which is housed in a low-rise building in Causeway Bay. It has a classy Chinese exterior, with the typical green slanting tiled rooftop and red pillars. In the movie, the enchanting tower-like exterior is a disguise: inside, the restaurant is altered into a crime syndicate full of installed trap devices. To get in, Billy has to first jump over the walls from the back of the building. As he gets into the unlit interior, a staircase in the rear leads him upstairs where he finds a *jodo* (a training hall for Japanese martial art) surrounded by Chinese antiques. A fighter with a distinct fighting style awaits Billy on each floor as he ascends. Defeating three of them, Billy finally arrives in the room of the big boss, who then has escaped to the rooftop through a secret passage behind the mirror. Billy follows but before he has time for action, the boss slides down the traditional Chinese rooftop and falls from the eaves.
➼ **Yip Kai-chun**

Photo © Wong Fei-pang

Directed by Robert Clouse
Scene description: Billy breaks into the secret base of the syndicate
Timecode for scene: 1:09:43 – 1:11:05 / 1:24:15

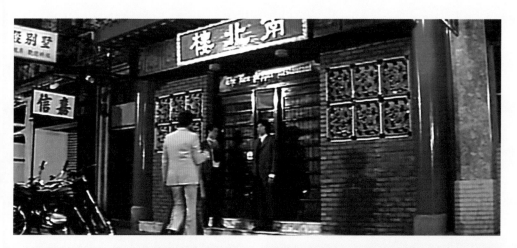

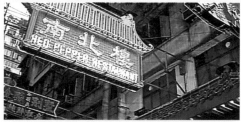

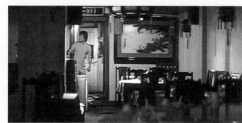

LOST SOULS (1980)

Squatter area (Tai Hom Village), Diamond Hill, Kowloon

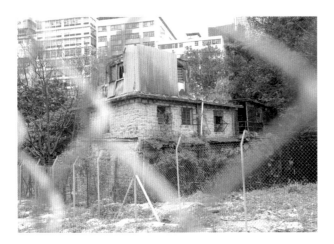

'**THIS IS NOT DIAMOND HILL.** This is not! This is not!' Tung collapses as he shouts, finally arriving in Diamond Hill, a dream place he has lived for. Set in 1980, *Lost Souls* is about people from poverty-stricken areas of Mainland China looking for a better life in the apparently more prosperous Hong Kong. To people in the colony, illegal immigration from China was both an economic and political issue. The film stages this controversy with its protagonist illegal immigrants falling prey to a group of bandits. They are inhumanly tortured, physically, mentally and sexually. Tung, one of the illegal immigrants, especially fancies Diamond Hill. He tells his girlfriend while swimming together across the border to HK, 'After reaching Diamond Hill where diamond is everywhere, we will have a good life.' In the midst of desperate suffering and danger, Diamond Hill has been the only goal that gives Tung the drive to endure all hardship. Obstacles after obstacles he survives, Tung is the only one in the group who succeeds in his escape to arrive in the urban area of HK. He finds his way to Diamond Hill only to discover that there is, of course, no diamond. In fact, Diamond Hill, the name of a district on the Kowloon Peninsula not far away from Kai Tak Airport, was predominantly a squatter area in 1980, where living conditions were no better than those in China. Diamond Hill exemplifies the lost hope of illegal immigrants in HK. ➻ **Yip Kai-chun**

Photo © Wong Fei-pang

Directed by Mou Tun-fei
Scene description: Tung arrives in Diamond Hill where hope turns to despair
Timecode for scene: 1:28:28 – 1:29:44

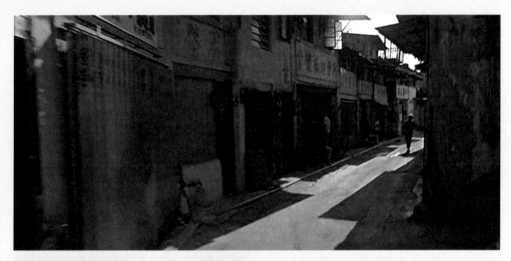

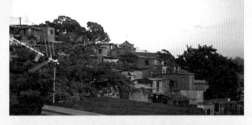

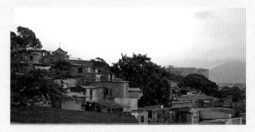

THE KID ON THE STREET

Dai pai dong, Tenement Buildings, Public Housing

Text by
LINDA CHIU-HAN LAI

'**THE SAME PIECE OF IRON** and steel could be turned into war weapons that destroy the world, or productive machines that benefit human kind.' This morally charged dictum is not about corporate ethics, but about children, also the quote that opens *The Kid*/細路祥 (aka *My Son A-Chang*, Fung Fung, 1950) in which 9-year-old Bruce Lee plays a kid who spends his days on the street.

Post-World War II HK Cinema contains a subaltern history of everyday dwellings for the ordinary Hong Kong person. The use of a location is far from a symbolic backdrop. A few 'places' have appeared repeatedly to form sub-genres without fixed dramatic conventions. Tenement buildings – a multi-family habitation with cubicles occupied by the poor … *Tong lau* – Chinatown-style low-rises with shops on the ground floor and residential use above. Hillside squatter areas … Public housing – also the resettlement of the squatter population … Cages and split flats – as in Chungking Mansion … To me, the 'primal scene'

of these lowly abodes is the street – epitomized by the kid(s) on the street(s).

A-Chang in *The Kid* lives in the backroom of a tenement building with his uncle and two little cousins. During the day, using a few boxes, wooden stools, and picture books hanging on a few lines on the wall, he sets up a small stall in a street-corner that gathers children who want to read with a meagre rental fee. The stall references Yuen Po-wan (袁步雲) whose comic strips provide *The Kid* its story. A-Chang's world is a series of precarious encounters between the tenement room and the street stall. Another prominent stall, right by the side of his 'reading gala', is a *dai pai dong* (DPD), a cart on wheels that serves prepared food, or simply prepares food on the spot, for drop-in customers. Regularly gathering there for a bowl of noodle soup is a group of jobless men. They take up temporary shady jobs from the capitalists, or pickpocket an arrogant rich man who happens to pass by. Sometimes a bit of a bully themselves, they also protect children who are bullied. In critical moments, though, they often manage to come to their senses to uphold righteousness. And they take A-Chang under their wings after he flees home, hoping to bring his uncle out of the tenement house into a big mansion one day by his make-doings. A-Chang is carefree on the street except when he's starving – unlike when he is at school, where he is rejected, or in the factory, where he is exploited as child labour together with other female workers. The noodle soup stall appears both as a movie set and as real locations; it is the place of fraternal solidarity, refuge for those outside the establishment. But what would become of street-kids remains an open question, to which the film endorses little hope.

Above © 1982 Feng Huang Motion Pictures
Opposite © 1950 Datong Film Company

The association of DPD to the poor is no pure cinematic imagination. DPD had been an object of the colonial government's perennial struggle – whether to kill street-hawking to suppress social disturbances or to encourage it to ensure social stability. The 1882 Chadwick Report suggested food stalls bred and spread infectious diseases. Street stalls were mobile and could go where business was, such as at horse races and soccer games. They had caused occasional fires – including the well-known big fire that burnt down the racing course in February 1918. Many complained they block the traffic, others against sound pollution due to street hawkers' yelling culture. To avoid provoking public rage, the government applied and raised annual licensing fees rather than prohibition. Advocates of licensing also argued that street-hawking promised to the poor the means to make a living, thus an indirect solution to contain social unrest. Within the Legislative Council, it was asked repeatedly: would we drive poor families to risky and illegal deeds if they lost the chance to hawk on the street, and to what would that leave their children? The concern for potential child crime underscored Legco discussions, and is also *The Kid*'s motif.

DPD was not differentiated from street-hawking until 1 October 1921, characterized as 'stall-holder hawker' as opposed to 'itinerant hawker'; further classification (valid until the 1970s) separated 'large cooked food stall', for congee, noodles and rice dishes, from 'small cooked food stall', selling coffee and tea with milk only.

The solution to the kid on the street in *The Kid* is to remove him from the street and from HK altogether. But children and young people on the street remain a prominent social discourse and space-bound imaginaries in cinema in the 1970s and 1980s. *The Delinquent*/憤怒青年 (aka *Street Gangs of Hong Kong*, Chang Cheh and Kuei Chih-hung, 1973) tells the typical story of a young man-turned-member of triad-gang that rules the streets of the Shek Kip Mei resettlement estate. *Cops and Robbers*/點指兵兵 (Alex Cheung, 1979) is primarily a story from the cops' viewpoint. But its expansive coverage of kids roaming through a public housing estate in East Kowloon is more than a pretext. Allen Fong's semi-autobiographical *Father and Son*/父子情 (1981) encapsulates a legendary historical moment – the birth of HK's public housing in the 1950s – as the protagonist's family loses their huts to a big fire that scrapped an entire hillside squatter area, and gets resettled to a flat in a public estate. In his next film, *Ah Ying*/半邊人 (1983), the young female protagonist spends the little time left from her daytime job selling fish at a street-stall on drama and film classes.

Crammed dwellings are physical-psychological entrapments fuelling rage and violence. The tenement building on film is a phenomenal exception. The tenement house in films like *In the Face of Demolition*/危樓春曉 (Lee Tit aka Li Tie, 1953), Yang Gongliang's *The Apartment of 14 Families*/一樓十四伙 (1964) or *He Ain't Heavy, He's My Brother*/新難兄難弟 (Lee Chi-ngai and Peter Chan, 1993) is the seedbed of the poor's communal charity against greedy landlords. ✢

Children and young people on the street remain a prominent social discourse and space-bound imaginaries in cinema in the 1970s and 1980s.

HONG KONG

maps are only to be taken as approximates

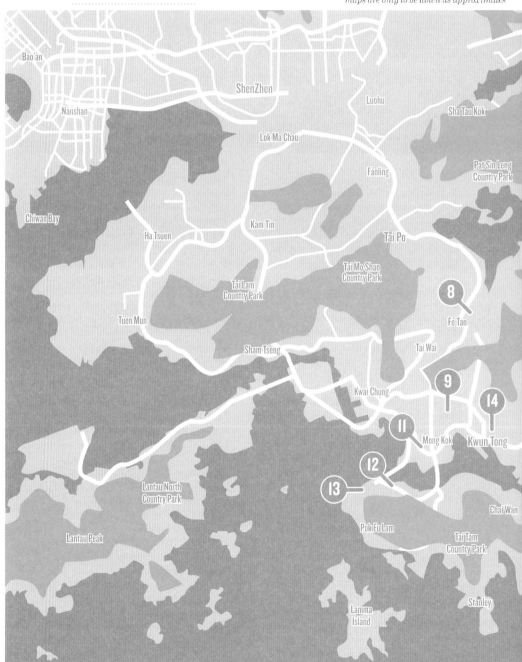

HONG KONG LOCATIONS
SCENES 8-14

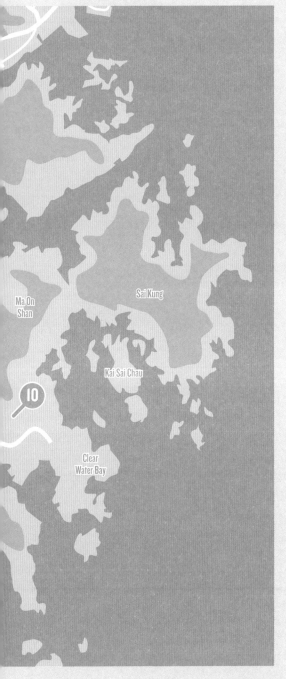

MAD MISSION (US TITLE)/
ACES GO PLACES (HK TITLE) (1982)

LOCATION *City One Shatin*

ACES GO PLACES is one of the top box-office hits from Cinema City, an independent film enterprise that adopted a 'collective work' method in the 1980s. This system aimed to ensure commercial success by avoiding artistic egoism driven by single individuals. For this movie, the decision was made to produce an action-comedy with a 'James Bond' flavour, which was a market guarantee at that time. The duo-protagonists not only rely on bare-fist kung fu fighting, but also 'high-tech' gadgets and car-racing skills in defeating the mult-national villains. The scene when they first meet has the newly finished high-rise private housing estate, City One Shatin, as the location-designate. The film plays with vertical space to produce thrill, suspense and comic effects. Hero King Kong has a special gun with which he builds sky routes from one skyscraper to another. But he decides to do old-school tightrope walking to get around. *Aces Go Places* makes use of various new urban projects – City One Shatin for King Kong's home, a new Central Business District for the villain's base, and a new industrial park as the location for its key car-chase scenes. These new spaces marked Hong Kong's successful transformation from a world factory to a developed city in the 1980s. As the Police Chief in the story suggests, it is HK's honour to house world-class criminals. Little had the audience back then imagined James Bond and his international villains would arrive in this soon-to-be financial centre of the world in the next few decades. **⤳Ho Yue-jin**

Photo © Wong Fei-pang

Directed by Eric Tsang
Scene description: Kong escapes from home by tightrope-walking
Timecode for scene: 0:38:29 – 0:44:28

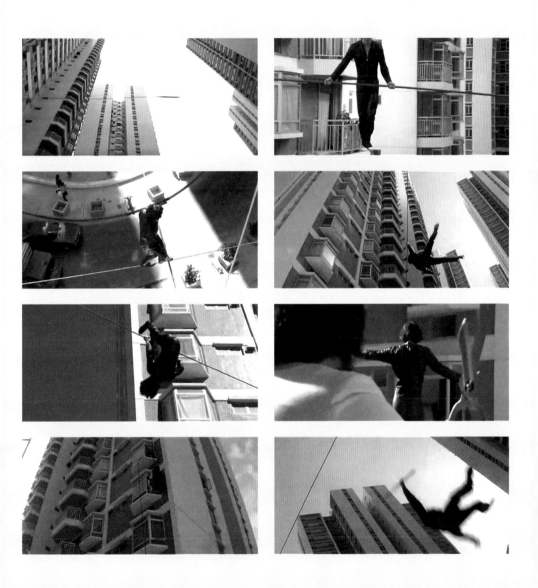

LONG ARM OF THE LAW (1984)

LOCATION *The Kowloon Walled City (now Kowloon Walled City Park)*

KOWLOON WALLED CITY was a unique urban space, with origins in Hong Kong's complex colonial history. Excluded from the 1898 lease that ceded the New Territories to the British, this six-and-a-half-acre enclave eventually became a political no man's land outside of both Chinese and British jurisdiction. After World War II, it became a densely populated haven for poor mainland immigrants as well as a bolt-hole for various criminal elements. Eventually reaching a height of ten stories in some parts, the place was a ramshackle labyrinth of tiny flats, shops, and even offices for (usually unlicensed) dentists and doctors, all connected by dark, narrow hallways strung with miles of electrical wiring and improvised plumbing. *Long Arm of the Law* stands today as one of the most significant pre-1997 ruminations on the stakes of HK's return to Chinese sovereignty. Here, this contemplation takes on a rather hysterical and paranoid tone, with the Chinese gangsters portrayed as violent invaders, although the film-makers are also cynical enough to have little sympathy for HK law enforcement institutions or home-grown gangsters. Contrary to this scene, though, which concludes with a Peckinpah-esque bloodbath and portrays the Walled City as a dangerous and claustrophobic trap, most residents strived to establish a genuinely functional community under very trying circumstances. Demolished in 1993 and 1994, the site and its unusual history are now commemorated by a rather lovely urban park. **Steve Fore**

Photo © Wong Fei-pang

Directed by Johnny Mak (Mak Tong-hung)
Scene description: Mainland gangsters and the Hong Kong police have a climactic shoot-out
Timecode for scene: 1:27:20 – 1:39:42

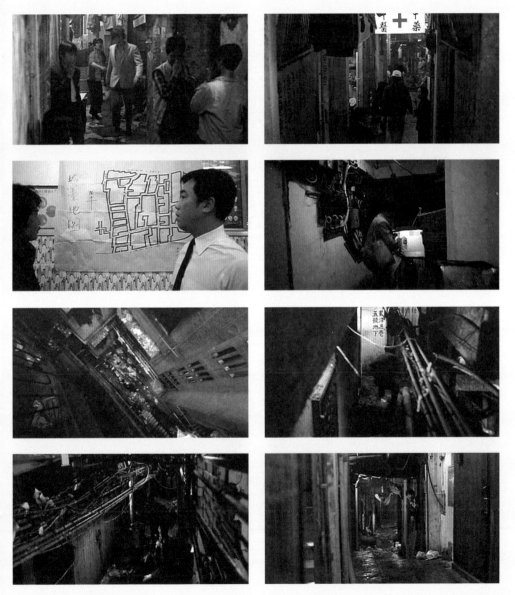

POLICE STORY (1985)

LOCATION *Squatter village above Anderson Road, Sau Mau Ping, East Kowloon*

HONG KONG HAS HAD AN ACUTE shortage of affordable housing since the first post-World War II wave of immigrants from China began to arrive in large numbers in the 1950s. Some of these recent migrants, then and now, find accommodation in what the government calls 'temporary housing', illegally constructed squatter villages and rooftop domiciles that continue to dot both the countryside and urban areas. This scene shows a hillside squatter village being largely destroyed in the course of a protracted gun battle and car chase. A typical vernacular improvisation of sheet metal, wood scraps and bamboo, the village itself does not appear to have been built for the film. Rather, my guess is that this particular village was already slated for demolition and that the film company arranged with the government or the landlord to stage the scene there. The government has had a policy of resettling squatter residents in the colonial period, especially in the immediate post-war era. In fact, this area of Sau Mau Ping was the past and future site of one of the largest quarry operations in HK, supplying crushed rock for the construction industry. The site is currently a strip-mined scar on the land, but the quarry is scheduled to close down and the site to be reclaimed and redeveloped into a residential zone and tourist destination. The views of Hong Kong Island from the high ground are spectacular. **↝Steve Fore**

Photo © Wong Fei-pang

Directed by Jackie Chan (Shing Lung)
Scene description: Inspector Chan stages an undercover-sting on a crime lord's gang
Timecode for scene: 0:02:53 – 0:11:45

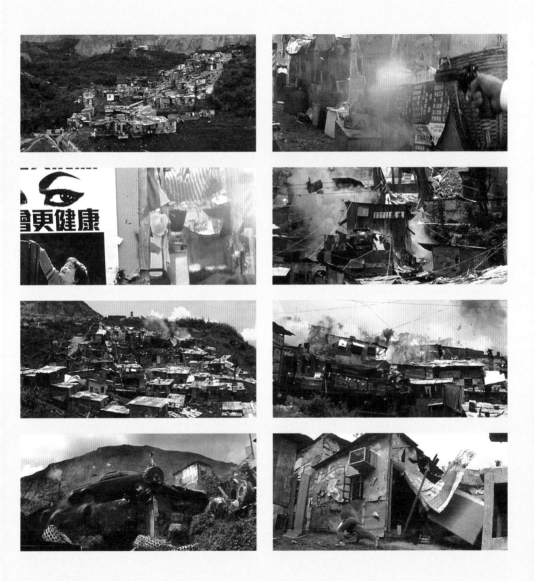

CITY ON FIRE (1987)

Nathan Road, Tsimshatsui, Kowloon

CITY ON FIRE creates a sense of insanity in its famous hectic chase scene: police cars pursue Ko Chow (Chow Yun-fat) along the bustling Nathan Road, packed with shops and restaurants and throbbing with shoppers and tourists. Chow dodges both passers-by and police as he scurries from Nanking Street to Prudential Centre in Jordan. During the actual filming of the scene, a van outfitted with a camera followed Chow, as he manoeuvred his way down this main road in Kowloon from Mongkok to Tsimshatsui. Complemented particularly with the sound of his desperate footsteps, the image of Chow darting through and across different streets seems a fitting metaphor for Ko Chow, the ambiguous guilt-ridden cop who has continually crossed lines between good and evil and who, as a consequence, finally falls victim to his circumstances. The complicated crisscrossing of strands of the cityscape is also an iconic metaphor, elucidating the internal struggles taking place within the police circles (for example, between Inspector Lau and his abrasive competitor John Chan) and within the gang (between the ruthless gang leader and his so-called 'brothers'). The portrayal of these antagonistic relations essentially leaves a subtle commentary on superficial presentations of police justice and gangster brotherhood. Incidentally, *City on Fire*'s box office success helped director Lam cross genre boundaries – as he then shifted from directing romantic comedies to action crime dramas with a noir flavour.
↝Kimburley Wing-yee Choi

Directed by Ringo Lam (Lam Ling-tung)
Scene description: Chase in a crowded urban area
Timecode for scene: 0:50:43 – 0:54:22

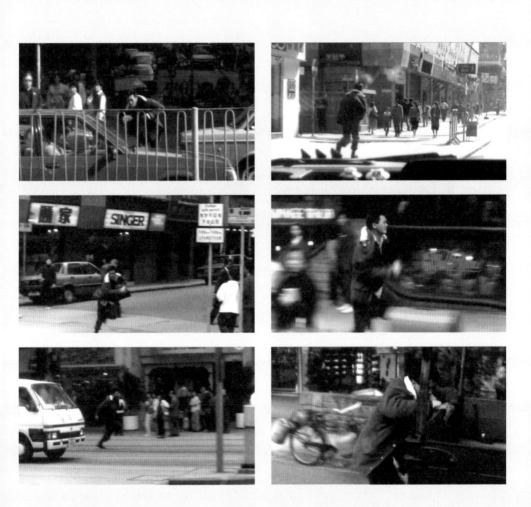

NOBLE HOUSE (1988)

LOCATION *Jardine House (formerly Connaught Centre until 1 January 1989), 1 Connaught Place, Central*

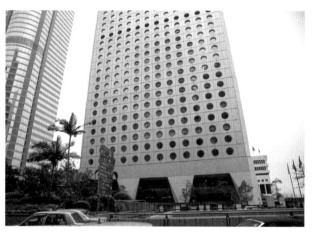

MINI-TV SERIES *Noble House* is about Struan & Co., the 'oldest' British-East Asian trading company, an obvious allusion to the Jardine-Matheson in Hong Kong's colonial history. Nothing coincidental, the series has the Jardine House in Central as its primary location for Struan's head-office. Jardine House was completed in 1972, then called the Connaught Centre, and was Asia and HK's tallest building. Struan is helmed by Ian Dunross (Pierce Brosnan). Many key dramatic moments unfold inside the building, with Dunross shot in front of the building's 'trade-mark' circular windows, showing the Victoria Harbour floating in the background like a drifting mindscape. Americans Linc Bartlett (Ben Masters) and Casey Tcholok (Deborah Raffin) come to Struan to brainstorm business. On the morning they are meeting, the camera follows Dunross driving downhill from the peak where Jardine House is visible from afar, rising sharp and sturdy from the landscape against the harbour. As he arrives, the camera lusts over a monumentalizing view of the building. Meanwhile, Tcholok arrives, intrigued by the slight tilt of the entrance. Dunross, displaying his knowledge of local culture, explains in feng shui (geomantic) terms: the tilt is 'for deflecting the devils getting in the front door'. The mystical side of HK startles Casey. Characters in the film repeatedly emphasize this aspect, hinting at the outlandish events in the plot. The geo-gravity of power plays out, too, by setting the office of Quillan Gornt, Dunross's corporate enemy, in World Wide House, opposite Jardine House across the road, like a sleepless watcher.
➻ **Yip Kai-chun**

Photos © Wong Fei-pang

Directed by Gary Nelson
Scene description: Bartlett and Tcholok arrive at the Struan's headquarter/
Gornt watches Struan at Connaught Centre from World Wide House
Timecode for scene: 0:25:24 – 0:26:29 / 0:28:19 (Episode 1)

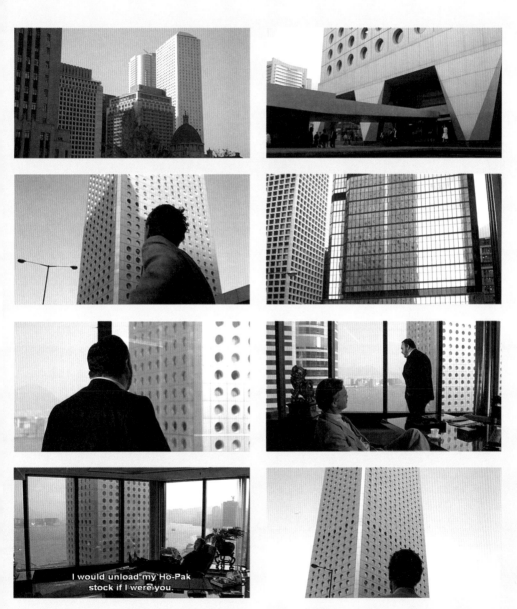

I would unload my Ho-Pak
stock if I were you.

ROUGE (1988)

Hill Road, Shek Tong Tsui

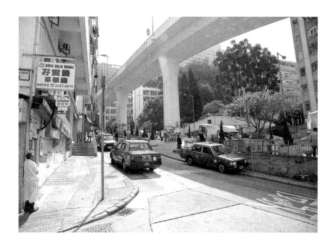

IN RESPONSE TO A FIRE that devastated several brothels in the Sheung Wan district, Governor Matthew Nathan ordered complete relocation of all brothels to nearby Shek Tong Tsui (STT) in 1904. Living in 1934, one year before the government outlawed prostitution and decisively transformed the district's physiognomy, courtesan Fleur (Anita Mui) inhabits a social world about to vanish. The evocative brothel scenes had to be shot in Macau because by 1988 STT's transformation was beyond recognition. Fleur returns to contemporary Hong Kong as a wandering ghost looking for her former lover. The narrative shuttles between past and present, highlighting irreversible urban transformation. Mirrors. Pastel colours. Sensuous camera movements ... The flashbacks are suffused with nostalgia for the irremediably lost past. Fleur's character is loaded with symbolic meanings. Referencing the old and new in contrast, she represents a passionate commitment thoroughly lacking in present-day HK. Once rooted in the district, Fleur now is a drifter. She enlists the assistance of Yuen, who works and lives in present-day STT, and so embodies for her a promise of belonging. One evening the two stroll around the neighbourhood where she used to live. As she observes the modern streets and remembers what they once looked like, viewers are invited to see HK through her eyes. Fleur becomes our consciousness: we step back from our present viewpoint and reflect on long-term historical changes. Through the identification with a ghost, the pain of losing the past becomes vividly real for a contemporary audience. *Rouge* is essentially a work of mourning.
⇢ Hector Rodriguez

Photo © Wong Fei-pang

Directed by Stanley Kwan (Kwan Kam-pang)
Scene description: *Fleur, accompanied by Yuen, visits the unrecognizable brothel area*
Timecode for scene: *0:34:27 – 0:35:53*

TO LIV(E) (1992)

Mu Kuang School, 55 Kung Lok Road, Kwuntong

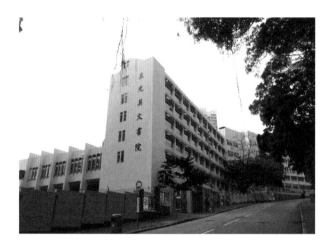

MU KUANG SCHOOL, uphill in industrial Kwuntong, was not a main location in *To Liv(e)*, my directorial debut feature. But it inserts into my tale of Hong Kong's near de-colonization a real-life presence with its founder Elsie Tu. Born Elsie Hume (1913) in Newcastle upon Tyne, she was a missionary in China with husband Rev. Elliot until 1949. Arriving in HK, they divorced and Elsie stayed. In 1954, assisted by Andrew Tu, whom she married decades later, she founded Mu Kuang for the children of squatters. The poverty and corruption that she witnessed drove her to politics in 1963 as an elected Urban Councillor. The colonial government's spying notwithstanding, Elsie 'the troublemaker' provided services to many underprivileged people. After the 1989 Tiananmen bloodbath, a colossal cloud of doom and gloom hung over HK creating waves of emigration. 'Should I stay?' magazine editor Rubie (the film's protagonist) struggles, anticipating HK's 'reunification' with a repressive motherland in 1997. In a series of letters from Rubie to Liv Ullman (the film's narrative structure), Rubie disagrees with the Norwegian actress-cum-human rights advocate's condemning of HK for repatriating Vietnamese refugees after her visit. Rubie and Elsie chat near Mu Kuang School. Elsie feels for the people she has served for three decades. Rubie ruminates on a HK trapped between big-power politics and human rights rhetoric, and personal commitment to a people and a place. Just recently, turning 100 and still at Mu Kuang, Elsie complained to me that postcolonial HK is coming full circle – all the bitter issues of social inequality that she combatted back then have returned with a vengeance ... •→*Evans Chan*

Photo © Evans Chan

Directed by Evans Chan (Chan Yiu-shing)
Scene description: Fictional character Rubie interviews the real Mu Kuang's Elsie Tu
Timecode for scene: 1:07:58 – 1:13:57

MANY-SPLENDOURED THINGS

The Wharf, the Roof-tops and the Floating Population

Text by
LINDA CHIU-HAN LAI

IN HIS TALE ABOUT DESPINA in *Invisible Cities* (1972, 1978), Italo Calvino speaks of how different modes of entry result in very different experiences of a place: 'the city displays one face to the traveler arriving overland and a different one to him who arrives by sea.' (Chapter 1 - 'Cities and Desire 3') Some Hollywood classics with Hong Kong as the 'playground' show there are indeed many ways to enter HK, but the visionary map they each draw, though varied in texture, has spatially channelled lust and caution with contrastive similarities.

In *Hong Kong Nights* (E. Mason Hopper, 1935), two American special agents arrive right into the heart of Victoria Harbour. *Love is a Many-Splendored Thing* (Henry King, 1955) opens with an aerial-shot whereby the camera embodies the arrival of a plane, also Mark Elliot (William Holden), via the western entrance of the harbour,

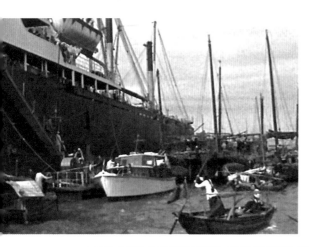

overseeing the Western District and Central. As the credits end, the camera descends, onto Queen's Road Central, Pokfulam Road and what's supposed to be Queen Mary Hospital, and from there the protagonists' romantic encounters spill over a few spots in the southwestern part of HK. *Soldier of Fortune* (Edward Dmytryk, 1955) anchors on Mrs Jane Hoyt (Susan Hayward) arriving seaward in HK. She disembarks an ocean liner at the Kowloon Wharf (in Tsimshatsui), where today's Harbour City is, then transfers to a connection motorboat to cross the harbour to dig into the depths of her husband's disappearance. Connaught Road West 464 (company of Hank Lee, played by Clark Gable) – she is told repeatedly – is where she should get help. Robert Lomas (William Holden) in *The World of Suzie Wong* (Richard Quine, 1960) also arrives in HK sea-wise at the Kowloon Wharf. As he heads for the Star Ferry, he takes us through a 'precious' walk linking the Wharf directly to Star Ferry passing by 'gate 51'. This passageway exists no more, with heavy shore reconstruction since the 1960s.

I imagine myself plotting these entry points and our visitors' subsequent locations on a map of HK. Scrap 50 per cent of the colony off the map. Keep the southern half. That, too, is the map at the start of *Soldier*. Include Tsimshatsui, southern tip of the Kowloon Peninsula: mark it the map's northern limit. Include the entire Hong Kong Island. Carefully mark the various floating population clusters along the Island's northern harbour shoreline, in Causeway Bay and Shaukiwan, and the cargo download activities in Sheung Wan. Only three main thoroughfares need keeping – Connaught Road (shorefront in Central and West), Des Voeux Road Central and Queen's

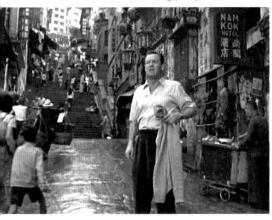

Above © 1960 World Enterprises
Opposite © 1955 Twentieth Century Fox Film Corporation

Road (East and Central). To connect the two sides of the harbour, keep three ferry services. Lomas and Suzie Wong (Nancy Kwan) in *World* meet on the Star Ferry. Mrs Hoyt and Mr Hank Lee in *Soldier* as well as Elliot and Han Suyin (Jennifer Jones) in *Love* cross the harbour in their motorcars using Yaumati Company's Vehicular Ferry service. The third pier to keep is in Sheung Wan – to allow the same two couples to retreat to Macao to liberate their restrained romance. Characters in *HK Nights* go to Macao, too, to solve the crime of the story. Keep the southwest corner of Hong Kong Island intact for Aberdeen, another fishing population with a floating seafood restaurant. Mark a few lookouts for the Victoria Harbour: from a roof-top in Wanchai, from the Western District above Pokfulam, from the harbour observing HSBC, and one full aerial view studying the shoreline of Kowloon from the Victoria Peak or a Peak Tram stop.

Some Hollywood classics with Hong Kong as the 'playground' show there are indeed many ways to enter HK, but the visionary map they each draw, though varied in texture, has spatially channelled lust and caution with contrastive similarities.

Where do the protagonists go after landing in HK? The director of *Love* leaves the two protagonists in absolute seclusion from the urban core to let them work out their forbidden relation. A hospital staff residence overseeing the harbour from the western mid-level and, from there, a path running upslope to an anonymous hillside mark the shuttling journey of their brewing relation. In a few instances, they retreat further. They dine in Aberdeen on a floating restaurant. On some isolated beaches near Repulse Bay, Elliott confesses he is married. Their love consummates in a stow-away trip to Macao … Only in the final sequence do we see Han, learning about Elliott's death, run through Queen's Road Central in desperation. She climbs the steps of Pottinger Street, and in the next shot she is seen on the steps of the hospital residence; from there she ascends to the hillside where union is only possible in eternity.

Lomas's journey after arrival in *World* is a compilation of daily routines with mashed-up locations. Out of the Star Ferry, he insists on walking to Wanchai for a cheap hotel. A two-and-a-half-minute sequence unfolds showing his baptism to local culture, setting Suzie Wong's story a Wanchai story, as he penetrates through the crisscrossing streets and lanes. Constructed on-location spectacles combine street-life varieties from different parts of HK onto one single stage called 'Wanchai': tenement buildings; lines of clothes hanging to dry; mobile street hawkers; stalls for prepared food, roasted ducks, salted fish and hanging dried snake-skins; a living snake on a man's shoulder; a homeless man with messy hair; pots and pans for sale; male gamblers … Then round a corner, Lomas finds his 'ideal' cheap boarding, Nam Kok Hotel, as he steps on Ladder Street north of Square Street, a real location 40 minutes away in Sheung Wan. In a few scenes, Lomas follows Wong to the squatter area where she hides her baby-boy. A few streets up from Ladder, they suddenly walk through Tai Hang Village, supposedly 40 minutes away from Wanchai to the east. Tai Hang, between Tin Hau and Causeway Bay, now totally cleansed, is a middle-class residential area.

Mrs Hoyt in *Soldier* books herself at the Peninsula Hotel in Tsimshatusui, but her activities are mainly on the road. Through her point-to-point search, we travel through Central and Sheung Wan with anthropological rigour: the famous Wing On Department Store, New World Cinema and Central Market on Des Veoux Central, the coolies at work on Connaught Road West and so on.

The floating population featured in all of these films show mixed usage of sampans as water-taxis, mobile grocery stores and ordinary households, but also dens of criminal secrets and erotic adventures, as in NBC-mini-TV series *Noble House* (NBC, 1988, starring Pierce Brosnan, based on James Clavell's 1981 novel). ✦

HONG KONG

maps are only to be taken as approximates

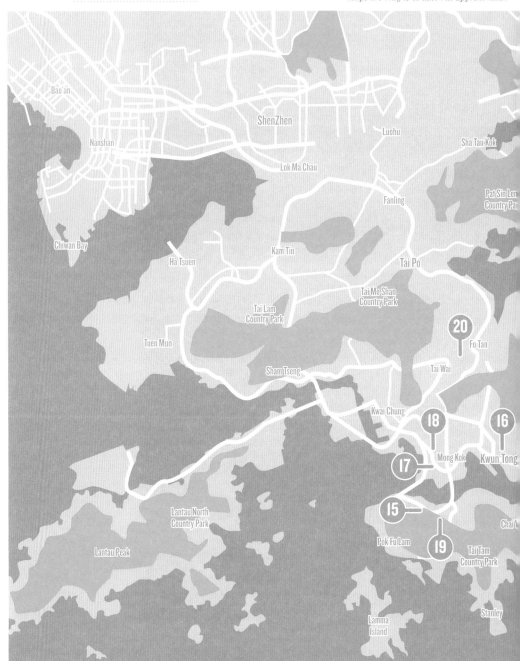

N

Bao'an

ShenZhen

Luohu

Sha Tau Kok

Nanshan

Lok Ma Chau

Fanling

Pat Sin Len Country Pa

Chiwan Bay

Ha Tsuen

Kam Tin

Tai Po

Tai Mo Shan Country Park

Tai Lam Country Park

20 Fo Tan

Tuen Mun

Tai Wai

Sham Tseng

Kwai Chung

18

16

17

Mong Kok

Kwun Tong

15

Lantau North Country Park

Pok Fu Lam

Chai

19

Tai Tam Country Park

Lantau Peak

Lamma Island

Stanley

HONG KONG LOCATIONS
SCENES 15-20

Sai Kung

Kai Sai Chau

Clear
Water Bay

CHUNGKING EXPRESS (1994)

LOCATION *Mid-levels escalator; Cochrane Street, 3 Lan Kwai Fong, Central*

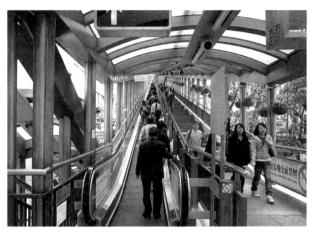

CHUNGKING EXPRESS gives a lyrical portrayal of urban space. Its melancholic characters are prone to nostalgic daydreaming and romantic obsession. But this lyricism is anchored in everyday reality. The moving handheld camera and jump cuts, together with abundant actual locations, gives an impression of life caught on-the-go. The film's English title references two key locations: the labyrinthine passages of the building complex known as Chungking Mansions, in Kowloon's Tsimshatsui, and the Midnight Express, a fast-food restaurant in the leisure area of Lan Kwai Fong, Central District. Each locale has a distinctive rhythm. Whereas Chunking Mansions is the site of frantic chases and nervous backdoor deals, a space of danger and action, the Midnight Express is a place for lingering and quietly contemplating. The film personalizes each location through the quality of the human activities taking place in it. Perhaps the most memorable location is the Central–Mid-levels Escalator and Walkway System, a twenty-escalator network in Central. Completed in 1993, Wong Kar-wai was the first director to use it in a feature film to explore its visual and expressive possibilities. When late one evening police officer 223 discovers that his girlfriend has another lover, he runs desperately up the steep, motionless, empty escalator. People are repeatedly shown reflected on its walls, creating echoes between different sections of the film. Another character, police officer 633, lives in an apartment directly overlooking the passers-by on the escalator. The window suggests connection and separation, expressing the tension between contact and flight that suffuses the narrative. ➡**Hector Rodriguez**

Photos © Bryan Chung

Directed by Wong Kar-wai
Scene description: Escalator conversations/lingering at Midnight Express
Timecode for scene: 0:17:41 – 0:17:53; 0:49:51 – 1:09:32

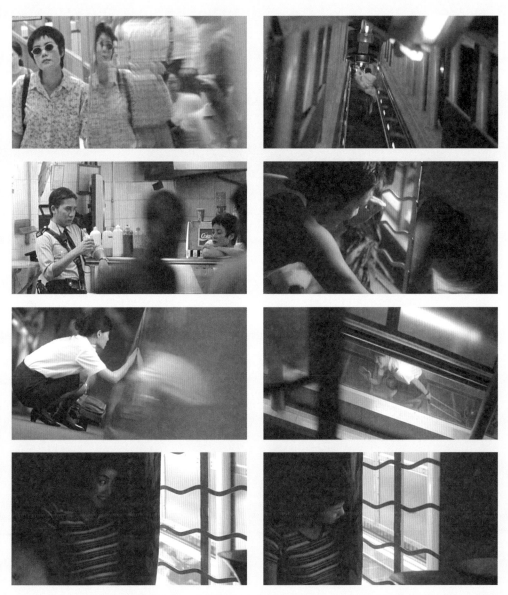

FALLEN ANGELS (1995)

Yue Man Mansion, Yue Man Square, Kwuntong, Kowloon;
MTR route between Kwun Tong station and Ngau Tau Kok station

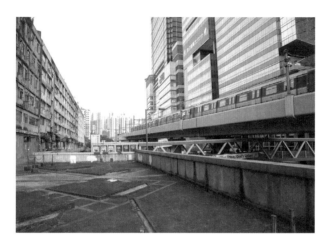

FALLEN ANGELS comprises two interweaving storylines of no causal relation: one is the bitter love story of a professional killer, Wong Chi-ming, and his female agent, the other about a mute man, Ho Chi-moo, who falls in love with a forsaken woman, Charlie. Though the characters in one storyline may cross paths with those in the other, their physical proximity does not bring them together for real encounters. Chi-ming's agent has a strong attachment to him. But rules of the game prohibit her from approaching her partner. That is the peculiar term of their collaboration: never get emotionally involved. For temporary relief from her intolerable yearning for Chi-ming, the agent travels back and forth by Kwun Tong via the metro-train whereat she looks out of the window for split glimpses of Chi-ming, whose dingy house is along the track. Imaginably, the ever-speeding train barely permits a successful glance. From her viewpoint, viewers only see a chain of blurred moving images that afford no recognition of a face or any details of his flat. The chance of encounter in the film is as indefinite as the flickering lines created by the drifts of light and shade. *Fallen Angels* purports a world of unknowing. Networks of human relationships or point-to-point spatial connectivity gather to gain form just to break down. With Chi-ming and his obsessive agent, their hauntingly intimate collaboration is also the very critical ties that denounce a stable, humane relationship, perhaps much like most ordinary people in our fast-paced contemporary society. ⇢*Lam Wai-Keung*

Photo © Wong Fei-pang

Directed by Wong Kar-wai
Scene description: Killer Chi-ming's agent attempting a glimpse of him
Timecode for scene: 0:33:42 – 0:34:47; 1:04:11 – 1:04:38

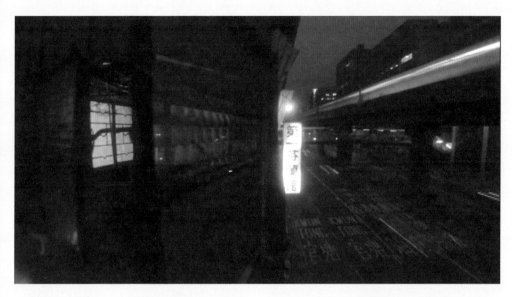

COMRADES, ALMOST A LOVE STORY (1996)

Silvercord Cinema, Canton Road, Tsimshatsui, Kowloon

COMRADES USES BICYCLING and the late pop-singer Teresa Tang's love songs to develop the romance story of Xiaojun (Leon Lai) and Qiao (Maggie Cheung), two new immigrants in Hong Kong from China. Through family connections, Xiaojun gets a delivery job and rides his bicycle every day through HK's fast-moving traffic. Cycling is used extensively in *Comrades* to suggest Xiaojun's innocence and his sense of freedom as he wanders in Tsimshatsui – a contrast to HK's hustle-and-bustle contemporary life. Qiao embraces HK's capitalist dream and works at the McDonald's. Despite their differences, romance blossoms between the two young newcomers after Xiaojun offers Qiao a bike ride in Tsimshatsui. Drawn to Xiaojun's cheerful ease, Qiao sings Teresa Tang's song 'Tian Mi Mi' (1979, the film's Chinese title, literally 'honey-sweet') as she leans on Xiaojun's back on the bicycle. They share a love for Tang's songs and enjoy each other's company. For various reasons, the two separate. By happenstance, they meet again at Xiaojun's wedding banquet a few years later. Qiao has become an entrepreneur and now drives a sedan. She ends up giving Xiaojun a ride in Tsimshatsui. In contrast to the days when they would ride a bicycle together, they are now like strangers to each other. An up-scaled material life brings the two immigrants bitterness and alienation. Nevertheless, during the car ride, Xiaojun finds out that Qiao still listens to Tang's songs, hinting that Qiao's love for Xiaojun has remained unchanged. Their fortuitous meeting and subsequent car ride together signal a love reborn. **↦Kimburley Wing-yee Choi**

Photo © Wong Fei-pang

Directed by Peter Chan (Chan Ho-sun)
Scene description: *Xiaojun offers Qiao a bike ride in Tsimshatsui*
Timecode for scene: *0:16:38 – 0:18:42; 1:14:02 – 1:17:38*

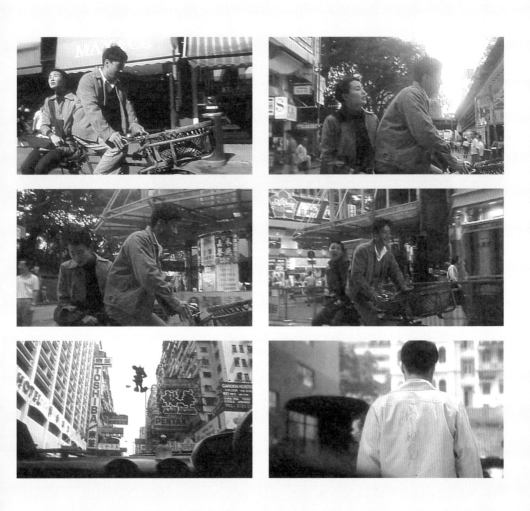

ONCE UPON A TIME IN TRIAD SOCIETY 2 (1996)

Dynasty Theatre, 4 Mong Kok Road, Mongkok, Kowloon

ON CALL BY BIG BROTHER, Dagger goes to Mongkok to join a gang-war. As night falls, gang-boys of different camps swarm the streets. Dagger only means to get by the day, but this time he cannot be less serious. The real triad world in the 1990s had lost much of its former glory: how many gang-boys really wanted to fight like gangster movies have imagined them? Director Cha is no ordinary genre director. Heroism is not what he hails but what he deconstructs. With little experience in a real fight, the gang-boys in *Once* wander the streets watching for the moment to slip away. Chance cheats. A casual 'hello' Dagger utters to a friend is taken the wrong way, which explodes into a dog-eat-dog gang-war. In the 1990s, Yaumatei, Mongkok and Jordan were gang-boys' hangout territories. The film, enacting a documentary impulse, took advantage of location shooting to include real pedestrians who might well be actual gang-boys. He plays with the ambiguity of reality and the filmic world's crossover. Cha also reconstructs his own gang-world by 'collating' a few disparate street corners though editing. One portion of the gang-war was shot in the lobby of Dynasty Theatre on Mong Kok Road. That was also where I watched this film that year. As I stepped out of the cinema, the street was full of youths and I couldn't tell if they were real gang-boys or not. The sheer number of youths was mesmerizing, and even created in me a sense of restlessness.
❖**Rita Hui (Hui Nga-shu)** *(trans. Kimburley Choi and Linda Lai)*

Photo © Wong Fei-pang

Directed by Cha Chuen-yee
Scene description: Dagger casually greets another gangster, mistakenly triggering a full gang-war
Timecode for scene: 0:49:00 – 0:54:00

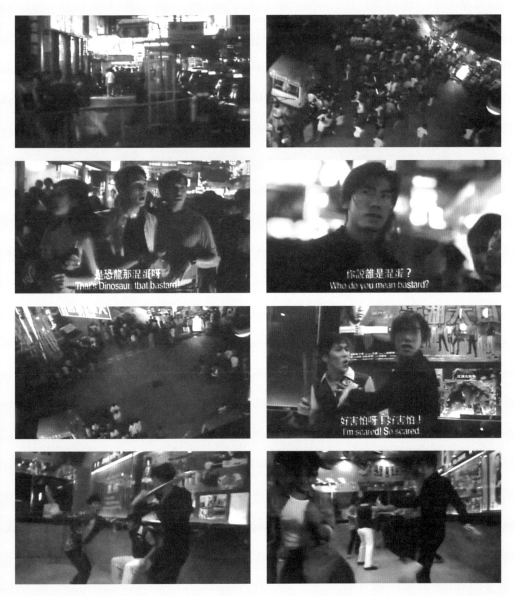

是恐龍那混蛋呀
That's Dinosaur, that bastard!

你說誰是混蛋？
Who do you mean bastard?

好害怕呀！好害怕！
I'm scared! So scared.

YOUNG AND DANGEROUS (1996)

Thomson Road, Wanchai, Hong Kong Island

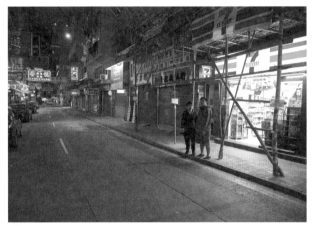

YOUNG AND DANGEROUS depicts the adventure of a group of young gangsters who eventually become the leading figures in triad society. The underground world in this movie is highly romanticized. Chan Ho-nam and his gang strictly follow a moralistic code: be loyal to your fellows, never harm the relatives of your enemy, and abstain from immoral deeds like drug dealing. Their main enemy is not the police but the 'bad' elements within the gangster world – those who violate the code. While the film's ethos is idealizing, the setting of the events is unusually 'ordinary' – when, say, compared with that of John Woo's works. There is no bloodshed machine-gun war on the streets or massacre of the innocent. Clandestine activities are properly covered in venues like bathhouses, game centres, membership-only casinos and other private quarters. In the final duel, antagonist Ugly Kwan is set up and trapped in a back alley of the busy night district of Wanchai. To ensure innocent passers-by are shielded from knowledge of or injuries from the fight, Chan arranges his sidekicks to guard the alley's exits. They keep away ordinary citizens by telling them a movie shoot is on. The desperate Ugly Kwan grabs a hostage to make a chance for his life – only for a rookie cop he insulted earlier to gun him down the moment he sets foot on the main street. As the film closes, hundreds of gangsters finally occupy the main road, proclaiming their leader, Ho-nam, the new King of Wanchai. **⟿Ho Yue-jin**

Photos © Wong Fei-pang

Directed by Andrew Lau (Lau Wai-keung)
Scene description: Final duel between Ho-nam and Ugly Kwan in an alley
Timecode for scene: 1:32:50 – 1:38:56

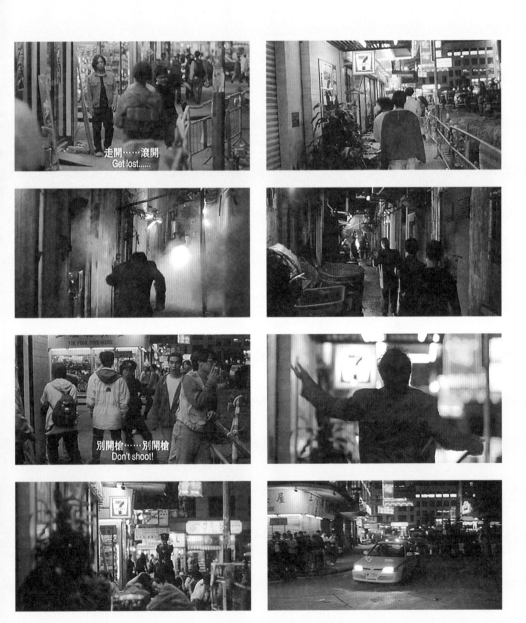

MADE IN HONG KONG (1997)

Lek Yuen Estate, Shatin, New Territories

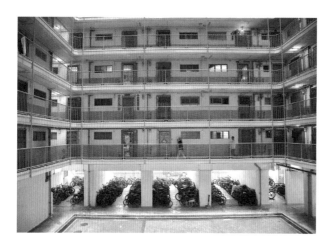

USING LEFTOVER FILM STOCKS and a minimal budget of half a million Hong Kong dollars, on its release, *Made in Hong Kong* successfully drew the attention of local audiences unfamiliar with independent productions. With a largely amateur cast, Fruit Chan depicts the lives of youths living at the bottom tier of society. Public housing estates where they congregate become almost a sure choice where their stories will unfold. Like all HK public housing, Lek Yuen Estate (LYE), completed in 1975, is densely inhabited and facilities are minimum but functional. One architectural signature of LYE is its well-like design, like Bentham's 'panopticon', except that the cylindrical structure is angular. Household units contiguously align with their front doors facing others' on each floor, creating a square-shape base of the atrium on the ground floor. All flats are connected by a passageway running around the inner wall of the well, which lets in sunlight to illuminate all households. Such a design allows everyone in the building to see other's daily activities even from a distance. In the opening scene, To Chung-chau, the protagonist, is introduced as someone working for a loan shark. Before his arrival, his target housewife is watching her neighbour on a lower floor being harassed by some so-called staff-members of a bank who press for payment. Eventually, a cop comes by to stop the harassment. Like her neighbours, the housewife is experienced in handling such situations – thanks to the 'convenience' of watching facilitated by the building, and To's debt-chasing job only ends in comic failure. **↝Ho Yue-jin**

Photo © Wong Fei-pang

Scene description: To Chung-chau collects debt from a housewife
Timecode for scene: 0:02:04 – 0:04:30

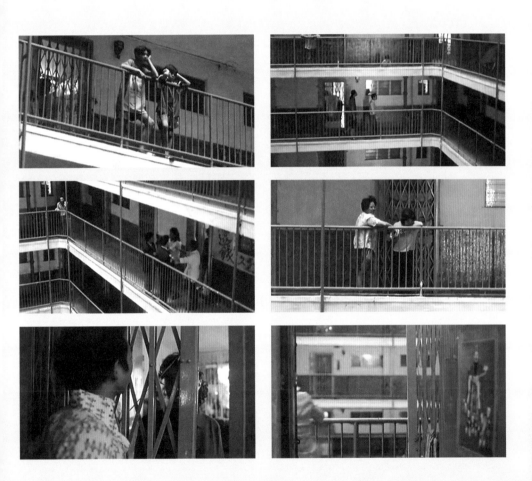

COLONIAL REMAINS

From Non-place to Self-referential Simulacrum

Text by
LAM WAI-
KEUNG

IN APRIL 1998, a year after Hong Kong's handover to China, the Film Service Office (FSO) was established to promote the development of the local film industry. One of FSO's functions is to facilitate film production and, in particular, location shooting in HK. It created a library with a large database of locations with which film-makers could find available premises for their filming needs. These include both government and non-government properties, ranging from ordinary residential sites to built heritage. Among these locations, there is a group of government-owned decommissioned premises that had once been the quarters or operation centres of the HK-British colonial government. Since the transfer of sovereignty to China, such premises increased in number. For varied reasons, they had been left vacant, to be auctioned to private property developers or redeveloped by the Hong

Kong Special Administrative Region (HKSAR) government with designated purposes. During the waiting period, these locations were available for filming at relatively low rental fees. Because they were mostly less accessible to the general population, they give a strong freshness to most audiences. The size of the vacant area of these locations also offered film-makers full flexibility in their production. There was a period of time when many films chose to use these places. As a result, many local movies, without meaning it, become visual legacies – together they form a virtual archive for a number of colonial remains whose existence managed to come into the general public's knowledge briefly before their final disappearance or displacement.

Different from those familiar film locations in the crowded urban areas, these colonial remains, long prohibited from public access, were non-places to the general public. Most local people were unable to relate their living experiences to these premises. Because of the public's lack of foreknowledge about these locations, they remained empty signs of colonialism and hierarchism. Their 'emptiness' has a double meaning: there is nothing in them, and the primary functions and activities that once filled these premises were voided. They await whoever the temporary users are to fill the space with their designate contents while maintaining a due sense of realism. In this context, most producers arbitrarily appropriated whatever 'original' contents were left behind there to suit their filming needs. In Andrew Lau and Alan Mak's co-directed gangster movie *Infernal Affairs II*/無間道 II (2003), the building of the Former Fanling

Magistracy appears in the guise of Kowloon West Police Station. The signage of the building was, of course, changed correspondingly. The movie posits audiences at a realistic perspective through which they unknowingly identify the Former Fanling Magistracy Building with another place that never exists in reality. There is no Kowloon West Police Station in HK! Transformation of an existing location into a fictitious place is common in the activity of cinematic creation; nevertheless, such technology of disguise acquires profound cultural meaning peculiar to the pool of movies in question. The decommissioned premises, upon emptied, became places of no valid identities. When standing alone, they merely were reference points to the past. But when they appeared in the guise of others – as in the case of *Infernal Affairs II* – or as what they once had been – in Peter Chan's ghost movie 'Going Home' in *Three*/三更之回家 (Peter Chan, 2002) with the Former Police Married Quarters on Hollywood Road, the disguise is self-referential as they point to a counter-part or a former phase of themselves. Only through disguise would these decommissioned 'non-places' resurrect to become visible once again. The prefix, 'Former', sufficiently manifests the indefinite status of these places' identities and the difficulties of their self-representation during the waiting period.

It is now the sixteenth year since HK's handover at the time of writing. Many of the decommissioned premises are now demolished whereas few are still in the prolonging ever-waiting period. In the year 2010, the Former Fanling Magistracy was classified a Grade-3 historic building and was included in the list of Revitalizing Historic Buildings to be managed through a Partnership Scheme initiated by the HKSAR government. In the same year, the Development Bureau announced that the Former Hollywood Road Police Married Quarters would be transformed into a new landmark for creative industries. Named PMQ 元創坊, dubbed 'the place to shine for the Hong Kong creative industries' on its website, it is scheduled to open in late 2013. Apparently the play of disguise carries on in reality but in reverse scenarios. Whereas the Former Fanling Magistracy Building will be modelled after its own past – a simulacrum of itself, the Former Police Married Quarters is going to experience a complete break from its past and return with a new identity though keeping its former name. The different fates of the decommissioned premises can be, to a certain extent, considered a range of allegories for postcolonial subjectivity experienced in HK – acceptance, denial or withdrawal – of which the true meanings can be recognized only when the subject is posited at an angle interfered by no refraction effect. ✠

Different from those familiar film locations in the crowded urban areas, these colonial remains, long prohibited from public access, were non-places to the general public.

HONG KONG

maps are only to be taken as approximates

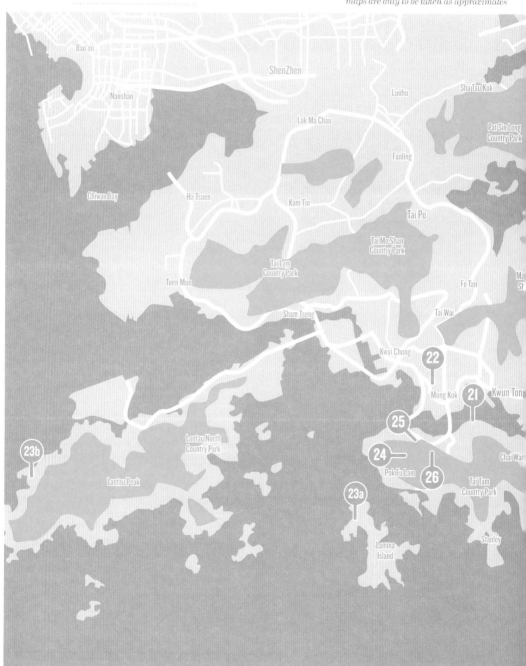

HONG KONG LOCATIONS
SCENES 21-26

Sai Kung

Kai Sai Chau

Clear Water Bay

BIO ZOMBIE (1998)

LOCATION *New Trend Plaza, no. 278-288 King's Road at Fortress Hill Road, North Point*

HONG KONG COMMERCIAL CINEMA often appropriates and transforms genre conventions. This horror comedy about a zombie contagion caused by soft drink bottles laced with biological weapons references George Romero's *Dawn of the Dead* (1978, 2004) and the Japanese computer game *Biohazard* (1996, aka *Resident Evil*), giving those motifs a local twist. Whereas *Dawn* was set in an anonymous, suburban mega-mall, *Bio Zombie* unfolds in the New Trend Plaza which has narrow passages crammed with small, inexpensive shops. *Bio Zombie* celebrates low-class shopping centres increasingly marginalized by high-class malls. The film's opening scenes take full advantage of this location. The two protagonists, Woody Invincible and Crazy Bee, are contemporary loafers who enjoy strolling around the Plaza while casually talking to passers-by. They run into two young women. The four eventually band together to combat a zombie plague. In contrast to the crowd anonymity of megamalls, this shopping centre is a place that facilitates socialization. Woody and Bee are social outcasts who seem made for this marginal space. They sell pirated videos in a tiny shop. They enjoy betting on horse races, devising practical jokes, playing computer games and abusing their customers. The characters and the location are perfectly matched. The two men prefer to kill time instead of opening their store. Their lives unfold on the margins of productive labour. Whereas inept police officers and other representatives of law and order are promptly turned into flesh-devouring zombies, the four outcasts become the film's heroes. *Bio Zombie*'s subversive outsider romanticism redeems an alternative experience of social space. **•Hector Rodriguez**

Photo © Wong Fei-pang

Directed by Wilson Yip (Yip Wai-shun)
Scene description: Woody-Invincible and Crazy-Bee kill time inside the New Trend Plaza
Timecode for scene: 0:01:00 – 0:06:30

 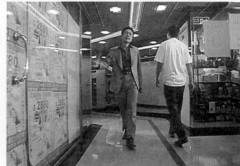

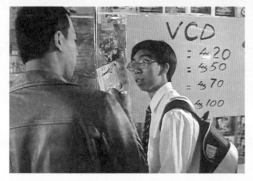

METADE FUMACA (2000)

LOCATION *On the stairs to a first-floor bookshop in a tenement house along Nathan Road, Mongkok*

AN EX-TRIAD HITMAN, Roy the Mountain Leopard (Eric Tsang), a 30-year escapee in Brazil, returns to Hong Kong to look for his former lover. On Nathan Road he comes upon an upper-floor cheap hotel inside a *tong lau* (that is, a low-rise building with shops on the ground floor and residential housing above). On the narrow stairways of the building, sales leaflets, advertising posters and shop-signboards adorn the interior like wallpaper. As Roy makes his way up, young street-smart Smokey (Nicholas Tse) and his call-girl friend (Tai Bik-chi) run past him from behind, pushing their way into a first-floor bookshop but reemerging in hardly a moment. On their way down, they brush past Roy again, which causes Roy's gun and Smokey's knife to fall on the floor. After returning the gun to Roy, the couple hurry away. Smokey has just wounded a man identified by his call-girl friend as having groped her. Little did Roy and Smokey know that their brief encounter on the staircase would bring them – two generations of street-smarts – true friendship through thick and thin. Three or four-storey low-rise blocks, some of them former tenement buildings, are still seen in some older districts of HK, with many small independent bookshops operating above the ground floor. In reality, the gang violence one sees in films is unlikely to occur in the crammed conditions of these upper-floor environments. Instead, they offer an exclusive and quiet reading environment for boutique-style bookshops, which has become a unique culture in HK. ⤚*Chu Kiu-wai*

Photo © Wong Fei-pang

Directed by Riley Yip (Yip Kam-hung)
Scene description: Staircase encounter inside a tong lau
Timecode for scene: 0:05:51 – 0:07:01

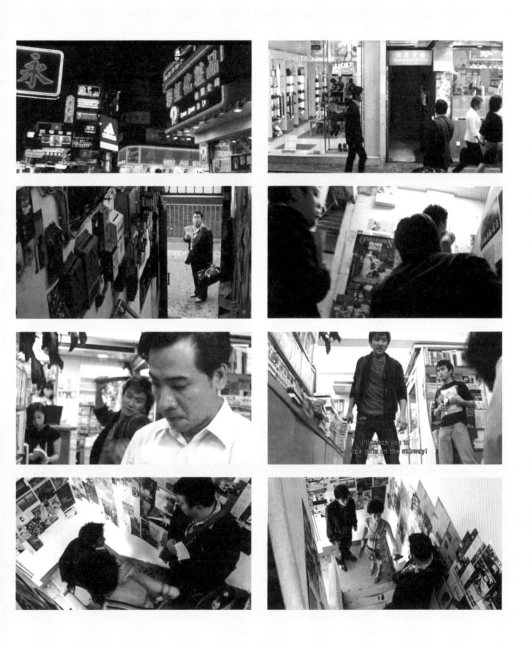

THE MAP OF SEX AND LOVE (2001)

Yung Shue Wan, Lamma Island; Tai O Village, Lantau Island

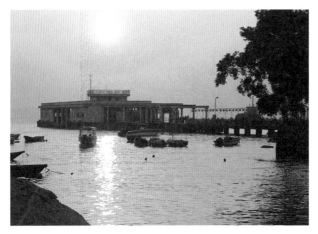

EVANS CHAN'S THIRD fiction film *The Map of Sex and Love* not only depicts the isolation of its individual protagonists using the metaphor of islands, but is also a quasi-documentary mapping the insular, coastal character of the twin Pearl Estuary cities of Hong Kong and Macau. Using four distinct themes – 'The Map of Sex and Love', 'Rubber Band', 'Belgrade' and 'Nazi Gold', this film reflects the fictional characters' lives ostensibly, but also the personal experience of the film's writer and director, subtextually. This personal, and indeed biographical, angle makes the film as much a map of Evans Chan, whose protagonist Wei-ming is to an extent his fictional counterpart, as it is of either HK or Macau. This reconciliation of the characters' inner subjective world with the external reality of Lamma Island, Lantau's Tai O stilted house village and the Macau waterfront, is the film's most remarkable achievement. Wei-ming's return to HK to shoot a documentary about the Disneyland project on Lantau Island, and his subsequent encounter with Lamma residents – avant-garde dancer Larry and troubled shop-minder Mimi – link the trio of human protagonists to the film's trio of primary locations. Shot in poetically allusive digital video by O Sing-pui, the film's memorable images of Lamma, Lantau, Macau and Hong Kong Island locations – including suggestively composed night and day shots of the Lamma ferry and pier – underscore John Donne's maxim that 'no man is an island'. HK and Macau's marginal and insular identity is, as Chan's film connotes, indissolubly linked with 'the main'. ➥ *Mike Ingham*

Photos © Wong Fei-pang, Yung Shue Wan, Old Pier (above left)

Directed by Evans Chan (Chan Yiu-shing)
Scene description: (1)Wei-ming and Mimi reminiscence about their dead mothers on Lama Island;
(2) romantic getaway in Tai O: recounting a fishermen uprising centuries ago
Timecode for scene: 0:51:49 – 0:54:34; 0:59:35 – 1:03:27

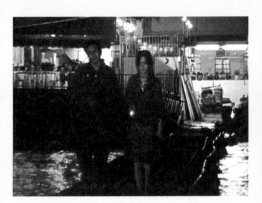 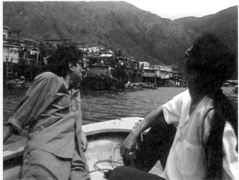

 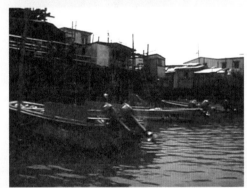

 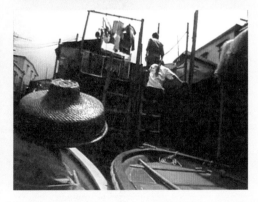

MY LIFE AS MCDULL (2001)

Peak Tram, Peak Tower and Peak Galleria

MOST HONG KONG PEOPLE do not have the resources to live on the Peak, and they usually do not visit the tourist attractions featured in this scene unless they have out-of-town guests. In this story, McDull's mother has promised her son a trip to the Maldives as a reward for taking his medicine, so she engages in a bit of well-meaning subterfuge to take the boy on a holiday that the family cannot otherwise afford. She settles for the Peak. In McDull's perpetually credulous mind, the Peak's vaguely art deco shopping mall is transformed into a tropical paradise, and the view to Lamma Island's iconic three-stack power station becomes a sighting of a palm-dotted atoll. As with most McDull vignettes, there is an undercurrent of melancholy and class tension, which here brews in the wonder trip of the Victoria Peak in HK for the Maldive Islands in the Indian Ocean. For readers interested, the view from the Number 15 bus's meandering trip up and down the slope is better than the straight-up cable-car trip from the Peak Tram. ⇢***Steve Fore***

Photo © Wong Fei-pang

Scene description: McDull's mother takes her son to the Peak
Timecode for scene: 0:30:38 – 0:32:35

GOING HOME (THREE) (2002)

Former Police Married Quarters on Hollywood Road, Central

INSIDE THE FORMER POLICE Married Quarters on Hollywood Road at Aberdeen Street is the home of Fai, the protagonist (Leon Lai) in 'Going Home' (a segment in *Three*). It is an archaeological site of Hong Kong's colonial history. Standing on the site in the nineteenth century was the Government Central School (1864–94), the first public school to provide western education to the local Chinese. Started on Gough Street, the School was re-allocated to Hollywood Road in 1884. After the foundation was laid, the school was renamed Victoria College until 1894 when the government gazetted its change of name to Queen's College. In 1948, after severe damage from World War II, the government developed the site into the Police Married Quarters, the first staff quarter for Chinese and junior police officers. The completed compound has two quarter-blocks and four plateaus, covering 6,000 square metres. In 2000, the Quarters was completely vacated and a revitalization plan was announced in 2007. In use since 1951, the Quarters has left behind many traces of history, such as ceramic floor tiles typical of the 1960s, blue-colour window frames, wooden doors, iron gates and glass panels with folds on the surface. These objects form the horror's backdrop, giving a material touch to the protagonist's isolation from the ordinary world. Time stands still inside the world of his dwelling. Fai craves stagnation to make space for his wife, who is dead, to return. The home is now almost without people whereas untamed memories are waiting to come home.
➼ Rita Hui (Hui Nga-shu) *(trans. Kimburley Choi and Linda Lai)*

Photo © Wong Fei-pang

Directed by Peter Chan (Chan Ho-sun)
Scene description: A policeman brings his child to an unoccupied estate and meets Yu
Timecode for scene: 0:01:14 – 0:53:51

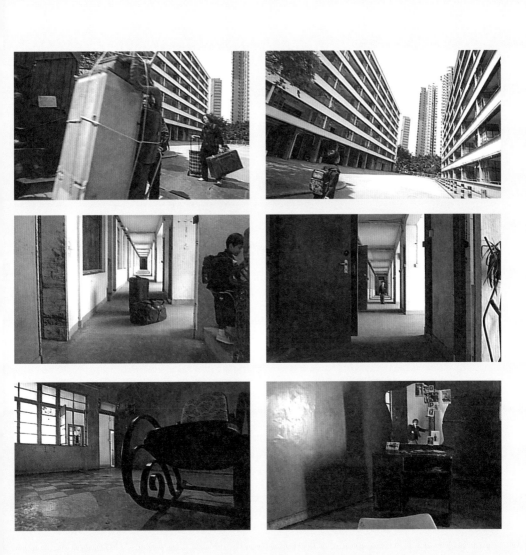

GOLDEN CHICKEN 2 (2003)

LOCATION *Peak Tramway, Victoria Peak*

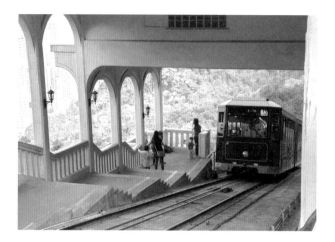

KUM (SANDRA NG) is a warm-hearted sex worker who chronicles the
humour and pathos of popular life in Hong Kong. In *Golden Chicken* (2002,
Samson Chiu), she tells stories of the past to comfort a suicidal robber in an
ATM booth. The sequel is set in 2046. Now 80, Kum spends the day at a Peak
Tram stop with a heartbroken young man who wants to take pills to forget.
To teach him that even sad memories are precious, she recalls 2003: the year
of SARS, mass protest and Kum's bitter-sweet affair with a mainland cousin.
Unbeknownst to the young man, this is his history too. From 1904 to 1942,
Chinese were forbidden to reside on Victoria Peak although they carried
sedan chairs up and down the hill. Opened in 1888, the Peak Tram funicular
was also reserved for non-Chinese during busy hours. Today, shuttling
between the shopping mall and hiking paths of the summit and the crowded
streets below, the Peak Tram whisks people up to fresh air and spectacular
views then plunges them back into everyday life. Alongside it nestles the
lovely, quiet 'stop' where Kum passes on her share of collective memory.
One of the city's secret places, here HK people can rest and enjoy the view
in peace. *Golden Chicken 2* ends with a hilarious farewell speech by Kum's
idol, 'Chief Executive' Andy Lau. This affirmation of the bonding power of
HK popular culture had a real-life counterpart on 25 May 2003, the day after
SARS infections reached zero. Thousands joyfully took off their masks and
converged for a day on Victoria Peak. **Meaghan Morris**

Photo © Wong Fei-pang

Directed by Samson Chiu (Chiu Leung-chun)
Scene description: Ah-Kum searches a Peak Tram stop for a man threatening to delete his memory
Timecode for scene: 0:01:08 – 0:03:36

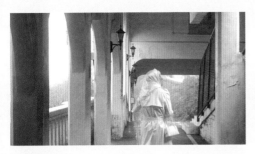
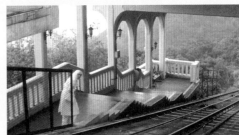
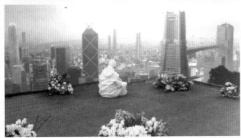

MY MOVIE SCENES

A Director's Impression of Home

Text by
DEREK
CHIU (CHIU
SUNG-KEE)

PERHAPS, SOME YEARS LATER, I may not be able to remember the superstars who have played in the movies I directed. But I believe, as I stroll down memory lane, that some scenes in these movies are forever firmly etched in my mind, even if those locations have evolved with time, bygone or not bygone.

A long, broad stairway lies at the start of Tin Hau Temple Road in Causeway Bay on Hong Kong Island, location of the New Eastern Terrace, a luxurious private residential compound. Shady trees on both sides, a tiny, tinplated stall stood alone by the stairway, selling small electrical items like light bulbs, wires and switches. At the top of this stairway, where a key scene in *Mr Sardine/*

沙甸魚殺人事件 (1994) was shot, stood an old weathered *tong lau*. Looking ghastly, it gave us the creeps during night-time shooting. Now, all these old buildings have been demolished, replaced by some luxury residences with hardly any character. Back then, the Tin Hau Temple had borne witness to the many changes in the district's history – the long and antique stairway, the steep cul-de-sac, the towering old trees and the archaic *tong laus* together form what is considered the charm of typical old-time HK. The aura of the spot provided a strong backdrop that highlights the autistic neat-freak in the movie, a neurotic deprived of any sense of security.

The Peak Galleria in *Oh! My Three Guys/*三個相愛的少年 (1994) – where the father of the protagonist (Eric Kot) screams 'You dead faggot!' – is now beyond recognition. Even the little fountain in the middle of the square has been filled up. I settled on this building for this film as it mildly alludes to the middle class – a facet of HK that is conventional and sensible.

*The Log/*三個受傷的警察 (1996) is a police story set on the New Year's Eve before the 1997 handover. Many scenes were shot at a desolate barrack on Austin Road, Tsimshatsui, formerly home to the British Army, then a station point for the People's Liberation Army Hong Kong Garrison troops since the handover. I used to drive all the way from Fairview Park to shoot my film in this colonial-style building, which was otherwise closed to the general public. For quite a long while,

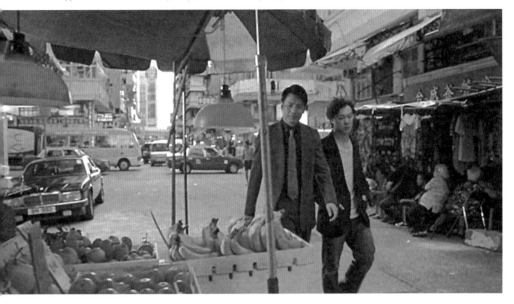

I would park my car nearby the barrack whenever I went to Tsimshatsui. Would this be one reason why I somewhat miss HK's colonial days? The colonial-style structures in the barrack plays a part in my story of HK's change of regime – particularly the scene of the senior officials' reception on New Year's Eve, in which people sing along to British anthems and ladies revel in the game 'Kiss the duck' as a hapless cop gatecrashes the party and kidnaps his own boss, pushing the scene to a tragic climatic end. It is this barrack in the heart of Kowloon that gives my film a strong historical flavour.

Then there is this ever-lasting Peng Chau – probably HK's most well preserved outlying-island community. The poignant lovelorn story of *Sealed With a Kiss*/甜言蜜語, (2000) is entirely set on this island. The opening sequence is a long-shot of a berthing ferry. The camera then pans to show the surroundings of the pier until a cut onto some long alleys where the protagonist (Louis Koo aka Koo Tin-lok) is ushered in. I shall never forget the little store facing the sea: its occupants do business in the front of a bungalow and live at the back. Peng Chau, with the surrounding sea, the alleyways and cottages, plain and tranquil, without any adornment, is the best place to nourish love.

What is to me the most authentic HK style? I would say Temple Street in *Ah Fai, the Dumb*/天才與白痴 (1997). Teahouse revues and the grassroots' many plebeian corners could be bizarre and whimsical, yet ooze communal humanity. In the movie, Idiot Fai grows up on this street. His mom is a street-singer, their neighbourhood a mixed ensemble of fortune tellers, porn-video sellers, street hawkers and small shop owners. Temple Street is far from a mere tourist hotspot – it is the very home of HK's lowly class.

I featured the wholesale fruit market of Yaumati in *Brothers*/兄弟之生死同盟, (2007). Among the rich hues and colours of piled-up produce live the city's earliest risers, who earn their living with their physical labour. Concealed by nectary fruits and worn-out facades is also a jumble of vices. I was drawn to this place because it is at once familiar and unknown to HK people. I set the gangster scenes in this historical fruit market – be it assemblies, discipline enforcement, sword-fights or gun-battles.

Looking back, being a homegrown HK director, I must have unconsciously set all my movie scenes with a love of HK. I had my camera capture places that I identified with. In each HK movie one finds a certain element of HK history. ✠

> **Among the rich hues and colours of piled-up produce live the city's earliest risers, who earn their living with their physical labour.**

maps are only to be taken as approximates

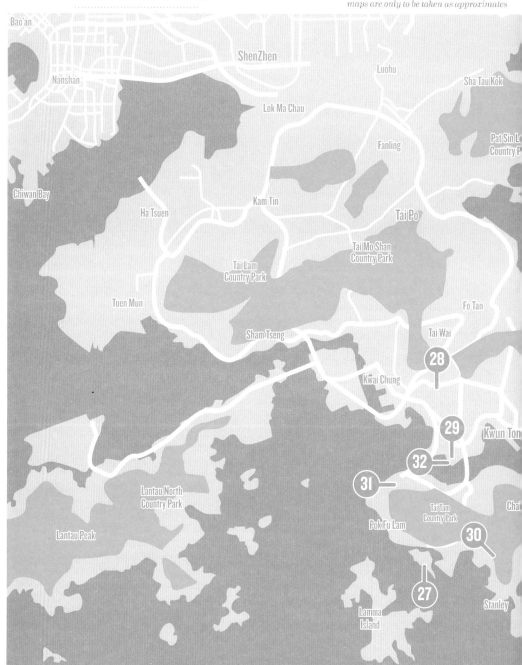

N

Bao'an

ShenZhen

Luohu

Sha Tau Kok

Nanshan

Lok Ma Chau

Pat Sin Le
Country P

Fanling

Chiwan Bay

Kam Tin

Tai Po

Ha Tsuen

Tai Mo Shan
Country Park

Tai Lam
Country Park

Fo Tan

Tuen Mun

Tai Wai

Sham Tseng

28

Kwai Chung

29

Kwun Ton

32

Lantau North
Country Park

31

Tai Tam
Country Park

Chai

Pok Fu Lam

30

Lantau Peak

27

Stanley

Lamma
Island

HONG KONG LOCATIONS
SCENES 27-32

PTU (2003)

Lee Nam Road and Lee King Street, Ap Lei Chau

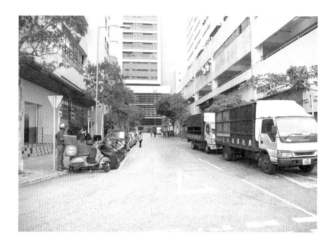

SERGEANT LO SA loses his gun during the assassination of a young triad member. The victim turns out to be the son of Bald Head, a godfather in triad society. Lo Sa seeks help from Sergeant Ho who, together with his patrolling team, agrees to delay the report of his loss and, instead, helps him find his gun first. Meanwhile, Bald Head agrees to return the gun to Lo Sa if he can arrange for him to meet the leader of a hostile gang so he may avenge his son's attack. During the film's climax, when all parties converge, an anonymous gang of robbers pass by the scene. They think they are under attack. A shoot-out is unavoidable. In the plot, the scene is supposed to happen in a busy night district and the name of the location, Canton Road in Tsimshatsui, is mentioned throughout the movie. Actually Johnnie To shot the entire sequence in a quiet industrial area, which has absolutely no resemblance to Canton Road. It is difficult to analyse his intention in such a short article, but perhaps the location better fits his visual aesthetics for a shoot-out. *PTU* has a more realistic look than many typical crime movies, yet it is highly stylized. Many scenes look as if they are oil paintings recording a historical battle. Some loyal yet confused fans of Johnnie To's tried locating the filming site, walking the entirety of Canton Road, one of HK's longest roads, but found nothing that looked even close. **↝Ho Yue-jin**

Photo © Wong Fei-pang

Directed by Johnnie To (To Kei-fung)
Scene description: Final game battle between all parties
Timecode for scene: 1:13:00 – 1:25:49

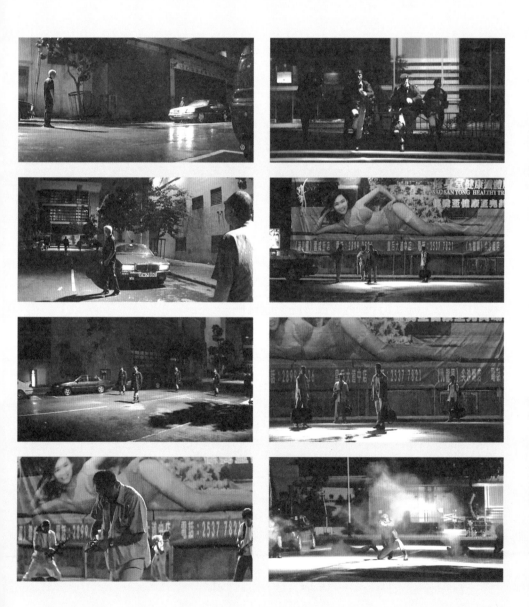

MCDULL, PRINCE DE LA BUN (2004)

LOCATION

A collage-compilation of generic cubicle units from Shamshuipo, Taikoktsui, Kwuntong, North Point, Sheung Wan

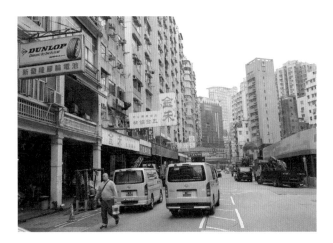

MCDULL, PRINCE DE LA BUN features piggie McDull and his working-class single mother, Mrs McBing, who struggles unsuccessfully to turn her pig-boy into somebody. Undifferentiated from humans, they live the ordinary life of many Hong Kong citizens. Perhaps the real protagonist is the narratorial performer – the film's constructivist animation work – a combination of hand-drawn daily events with a 3D collage-compilation of HK's cityscape based on trace-drawings of photographs on HK. The narrative backbone is Mrs Mc's attempts to read Harry Potter at bedtime as her son requests, only to always end up telling surreal versions of her husband's life. The real story is the difficulty of storytelling, as the film comprises loosely structured and elliptical scenes crossing the borderline between documentation and fabrication. Events are inconsequential; narrative communication breaks down. Viewers' compensation is the bulk of fragmentary visual spectacles sampling the doings and makings in everyday HK. The ficto-animated-documentary narrative, the makers' surrogate, screams of the cruel facts of urban renewal initiated around 1997 – old neighbourhoods being collapsed to make room for property magnates' new projects. Trivial and neurotic though the mother and son's encounters are, they underscore HK's burden of globalization, the desire to be on the map of international affairs of significance. In an early sequence, McDull is in a kindergarten, shaking his legs compulsively while learning absurd survival tricks. The rhythm of leg-shaking mysteriously connects with that of HK's urban landscape, where construction, demolition and reconstruction synchronize in one constant shake-up. Is this a tale of HK, or a curse in enchanting disguise? **➻Linda Chiu-han Lai**

Photo © Wong Fei-pang

Directed by Toe Yuen (Yuen Kin-to)

Scene description: *McDull's compulsive, rhythmic leg-shaking*
connects with the pulse of urban demolition
Timecode for scene: 0:02:29 – 0:08:00

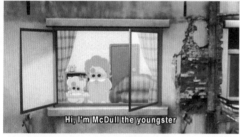

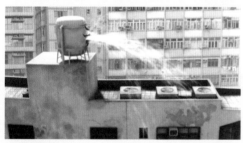

THROW DOWN (2004)

Ashley Road, Tsimshatsui

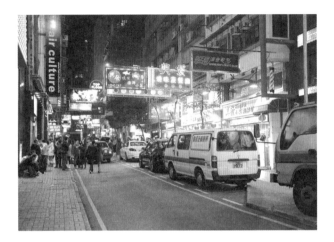

IN *THROW DOWN*, Szeto Bo's (Louis Koo) bar is located on Ashley Road, Tsimshatsui. Back in the 1990s, Ashley Road was a perplexing landmark to many, remembered for its Amoeba Bar, after which a chic magazine was named, and My Coffee, the coffee shop in Wong Kar-wai's *Fallen Angels* (1995). It was a time of blooming youthful energies; and the street an intimate hub where young people loved to hang out to give the location its character. Since 2000, heavy construction has sprouted all around this little street and, without much anticipation, Ashley sank like a submerged alley with no way out. High-rise buildings closing up on it are like the tall walls of a fortress, disjointing Ashley from the rest of bustling Tsimshatsui, leaving the bar behind as the token of oblivion. Surpassed by Lan Kwai Fong in Central, Hong Kong Island, the street and the bar retain no more visitors like the case for a failed drama event – perhaps except Szeto Bo's customers, Tony and Mona – people with no paths to take ahead of them. And they hang out here, crafting a Judo game with the still-functioning theatrical lightings.
⇝Rita Hui (Hui Nga-shu) *(trans. Kimburley Choi and Linda Lai)*

Photo © Wong Fei-pang

Directed by Johnnie To (To Kei-fung)
Scene description: Lee Kong wages a duel with Sze-to Bo
Timecode for scene: 0:39:37 – 0:42:12

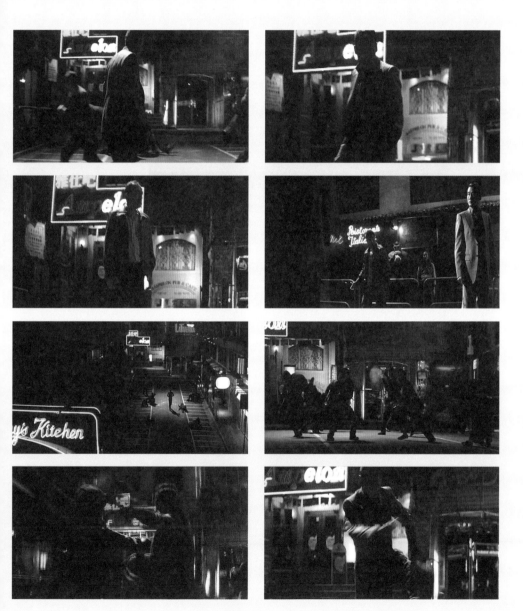

BOARDING GATE (2007)

The Repulse Bay (former Repulse Bay Hotel) in Repulse Bay

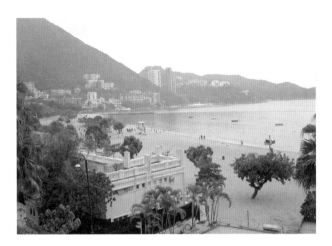

IN A PARISIAN UNDERWORLD of illegal trades, a former sex worker, Sandra (Asia Argento), is under life-threatening pressure to kill Miles (Michael madsen), an influential businessman, for her boss-cum-lover Lester (Carl Ng). When the job is done, she escapes to Hong Kong, ordered by Lester, who also issues a fatwa to silence her. Although she manages to save her own life, deep feelings of betrayal lead her to track down Lester for revenge at the Repulse Bay, an up-scale residential community with a clubhouse, colonial-style restaurant and shopping complex. Lester meets Miles's business partner Andre (Alex descas) inside the restaurant to collect his reward for putting down Miles. Lester is right there for Sandra, but the volume and flow of customers prevent her from taking action. At the lobby exit, an opportunity comes for Sandra as Lester makes his way out. But she hesitates and, under her watchful eyes, lets Lester drive away. The Repulse Bay, standing on the site of the demolished Repulse Bay Hotel (1920–82), is the setting of many romance movies, including *Love is a Many-Splendored Thing* (Henry King, 1955) and *Love in a Fallen City* (1984, Ann Hui). The original British-colonial-style hotel veranda is kept as an integral part of the reconstructed restaurant. Is Sandra's reluctance to exercise revenge due to memories of her times with Lester triggered by Repulse Bay's romantic setting? Having the men close the deal in this location seems an obvious allusion to the conflicting aura of idyllic peace and the epic intensity of failed romance. ➼*Chu Kiu-wai*

Directed by Olivier Assayas
Scene description: Failed revenge at the Repulse Bay
Timecode for scene: 1:39:15 – 1:43:25

LUST, CAUTION (2007)

LOCATION *Main Building, Campus of the University of Hong Kong, Pokfulam*

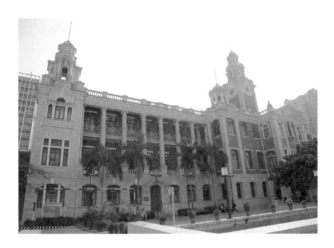

IN 1938, as Japanese aggression escalated and many Chinese territories fell to Japanese occupation, many young intellectuals escaped to Hong Kong to carry on their higher education. At the University of Hong Kong (HKU), conceived in 1910, Chinese and western teachers and students have congregated as a pluralistic community, in a British colonial yet liberal intellectual atmosphere. In the Main Building on campus, patriotic Chinese young man Kuang Yuming (Wang Lee-hom) meets Wang Chiachi (Tang Wei) and Lai Shujin, two female classmates from Shanghai. He invites them to join the drama society he has founded. The plan is to participate in a play performed at Loke Yew Hall inside the main building – to raise funds for an anti-war campaign and to wake people up from their leisurely and carefree life in HK. As night falls, the two girls are seen sitting by a lotus pond, discussing whether they should take part in the activities. Their decision could put them on a path of no return – of involvement in 'anti-Japanese' spy activities. Officially opened in 1912, Main Building is the oldest building at HKU and has been declared one of HK's 99 historical monuments. Supported by solid granite columns, the Renaissance-style piece of architecture has in its centre court a lotus pond around which people can sit and rest, in a harmonious East-meets-West cultural setting. It has been a hundred years since it completion, but the century-old setting remains unchanged.
⇢Chu Kiu-wai

Photo © Wong Fei-pang

Directed by Ang Lee
Scene description: Anti-Japanese sentiments flourish on campus at HKU
Timecode for scene: 0:16:35 – 0:18:48

ONE-WAY STREET ON A TURNTABLE (2007)

LOCATION *Victoria Harbour – from Central,*
Hong Kong Island to Tsimshatsui, Kowloon

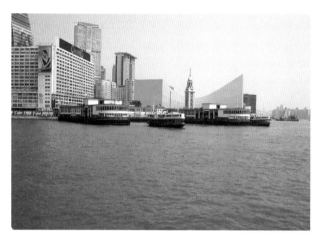

ONE-WAY STREET ON A TURNTABLE is about Hong Kong history, specifically the idea of 'home' and personal histories based on memories of space, and the kind of historical knowledge they generate. I shuttle between the old and the new, public and private, political and personal, and moving and rootedness to form the film's structure. These seemingly oppositional pairs are poetically interwoven. Victoria Harbour has long been a cliché and yet an important symbol of HK. It has been widely mentioned in school textbooks and tourist guidebooks since the 1960s. Juxtaposing the colourful/ fine 16 mm (1970s) with the black-and-white/grainy super 8 (2006) film footage, I engage my audience in reflecting upon the changes in the HK cityscape via their personal memories. The soundtrack is a voice-over from publicity films the British colonial government made to promote HK as an international, modern Asian city. The voice seemingly offers a factual account, as in typical expository documentary, about Victoria Harbour, Star Ferry, local geography and HK people in general, which amount to the discourse 'Hong Kong has everything!' Obvious irony. This sequence of overt optimism stands in contrast with recent urban re-development plans that blindly abolish some important landmarks and pertinent communities, including the Edinburgh Star Ferry Pier, which, in my work, comes right after the promo sequence. The 'voice' from Public Service Announcements creates a double commentary on the images of Victoria Harbour shown on a split-screen – at once personal spatial memories and a reflection on social and political changes. ➻ ***Anson Hoi-shan Mak***

Photos © Anson Hoi-shan Mak

Directed by Anson Mak (Mak Hoi-shan)
Scene description: *Crossing the Victoria Harbour on Star Ferry*
Timecode for scene: *0:20:32 – 0:22:24*

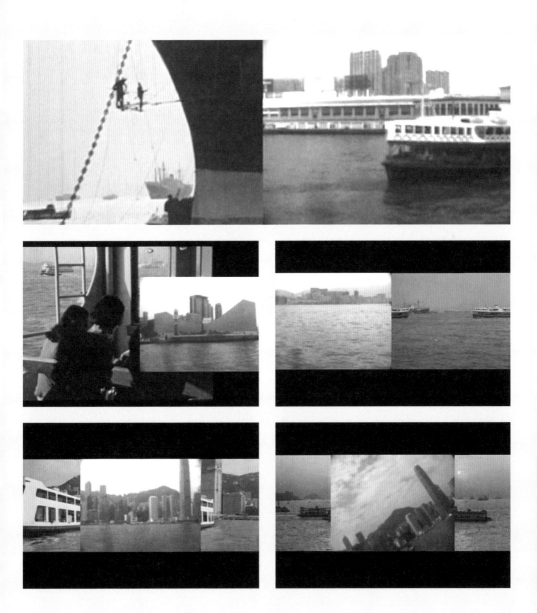

VICTORIA

Room With a View, or Unsettled History?

Text by
HECTOR
RODRIGUEZ

RECENT POLITICAL AND social movements in Hong Kong have coloured the image of urban space in audiovisual media. The 2007 public demonstrations against the government's decision to demolish the historic Star Ferry and Queen's Pier in Central District, for instance, signalled a rising public awareness of the politics of public space and the disempowerment of the common citizen. Recent street protests have also addressed economic inequality. Urban space is at once a valuable commodity and a political battleground.

Dream Home/維多利亞壹號 (Pang Ho-cheung, 2010) uses slasher-film conventions for social commentary. The narrative's extreme physical violence brings to the surface the psychological and economic violence at the heart of HK's property market. Pang's film shows how urban space cannot be disengaged from socio-economic circumstances. Its protagonist Cheng Lai-sheung (Josie Ho, also the film's co-producer) pursues her single-minded goal of purchasing an apartment in a modern private estate overlooking Victoria Harbour. Few local films have expressed the sheer intensity of the local population's desire for home ownership and the anguish of millions excluded

from the possibility of its fulfilment. It takes the horror genre to capture the extent of this madness and despair.

A few eerily empty shots of an estate's public areas open the film, followed by the brutal murder of a security guard. And that is only the first in a series of ultra-gory murders that Lai-sheung will carry out throughout the building, using such common everyday items as a kitchen knife and a cable-tie. The rest of the film juxtaposes the methodical execution of this massacre with flashbacks that reconstruct her childhood and recent life. What has led this young woman to perform such gratuitous butchery? The narrative evolves progressively towards an explanation of the reasons for this act. In her early childhood, ruthless property developers rely on gangsters to intimidate her family into vacating their home, which has a stunning harbour view, to make room for the construction of profitable apartment complexes. The rest of her life is lived under the sign of this primal trauma – the deprivation of a home with a harbour view. Her desires are shaped by an economic system that renders the common citizen subject to unpredictable forces. A sudden stock market fluctuation, for instance, encourages the owners of her dream home to increase the price – and this triggers her massacre. She kills to lower the property's value. The bloodshed to which she resorts partakes of the cynical economic logic of the property market. Her extraordinary act of carnage holds a mirror to the ordinary viciousness of HK capitalism, which systematically disenfranchises people – the horror at the heart of the film.

Images of Victoria Harbour connecting the private life of the film's protagonist with a wider political environment also underpin Johnnie To's *Life Without Principle*/奪命金 (2011). The global financial crisis and HK's precarious economy impregnate television screens as the voice of news announcers ruminates on the textured soundtrack.

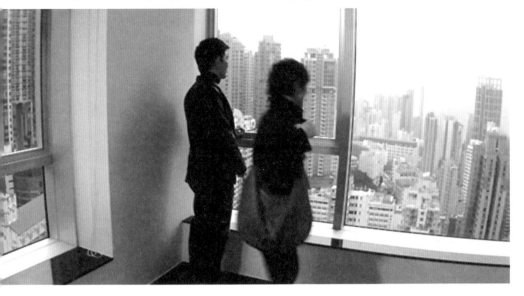

The thickening tension of the film's rich media landscape intermittently slides into breathing shots of an overcast Victoria Harbour. A policeman's wife insists, in a manner that recalls *Dream Home*'s protagonist, on purchasing an apartment with a harbour view. Her real estate agent presses her to take immediate action before Chinese investors bring up the interest rates. The lives of the protagonists in *Life Without Principle* are shaped by market forces they cannot understand. Both films depict a city whose institutions systematically reward manipulative tactics. Their characters must adapt to this environment.

Victoria Harbour also figures in Linda Lai's 24-minute experimental video, *Voices Seen, Images Heard*/看得見的聲音, 聽得見的形象 (2009). Using montage techniques with a collage effect, she compiles images of Victoria Harbour of contrasting textures from diverse sources (1930s–2008), including photographs, feature-film locations, newsreels, travelogues, personal diaries and found web-videos. *Voices* poses the question of the formation of an audiovisual archive in the context of a fragile history. It dramatizes the difficulty of our access to the past, when that access is mediated by images and sounds made with implicit subject positions. What HK history do we get when the necessary documents are all heavily mediated? There is no voice of authority, no definite meaning of history. The material is never presented as if it were the 'truth' of HK's past. Victoria Harbour is ever changing – each image-fragment of the harbour points to a different moment of HK, of a different aura, and overtly functional appropriation of the harbour shores. The finale is a subtle, critical response – re-edited YouTube footage shows the local people gathering for the last chimes before the government dismantled Star Ferry's clock tower. *Voices* is a poetic and self-reflexive work that emphasizes the process of the quest for a spatial history. It subtly diverts Victoria Harbour's image history from that of economic gain, to contemplate the loss of collective experience spatially embodied.

All these three films scramble and fragment the narrative timeline, encouraging viewers to reflect on the process of making sense of HK history and society. They remind us that the meaning of the city's past legacy and present condition cannot be taken for granted. ✢

> Victoria Harbour is ever changing – each image-fragment of the harbour points to a different moment of HK, of a different aura, and overtly functional appropriation of the harbour shores.

Note: The full work of *Voices Seen, Images Heard* was published in *ASPECT: The Chronicle of New Media Art* (vol. 18, 2011).

maps are only to be taken as approximates

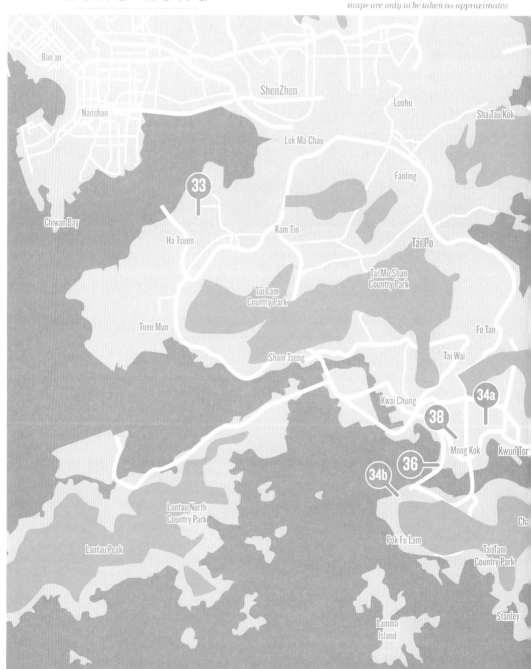

Bao'an

ShenZhen

Luohu

Nanshan

Sha Tau Kok

Lok Ma Chau

Fanling

33

Chiwan Bay

Kam Tin

Tai Po

Ha Tsuen

Tai Mo Shan
Country Park

Tai Lam
Country Park

Fo Tan

Tuen Mun

Sham Tseng

Tai Wai

Kwai Chung

34a

38

Mong Kok

Kwun Tor

36

34b

Lantau North
Country Park

Pok Fu Lam

Tai Tam
Country Park

Cha

Lantau Peak

Lamma
Island

Stanley

HONG KONG LOCATIONS
SCENES 33-38

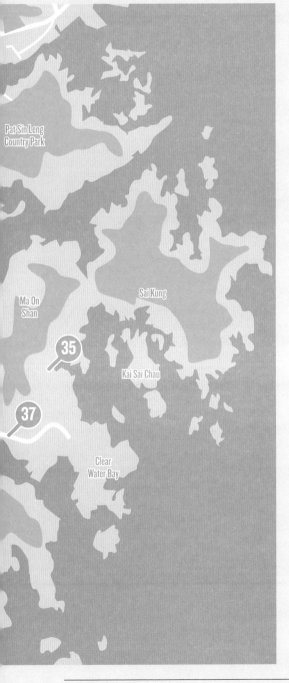

THE WAY WE ARE (2008)

TIN SHUI WAI (TSW) New Town is one of the more recent public housing estates the Hong Kong government has built since the 1950s to cope with the booming population. These estates are intended to be self-contained towns in the peripheral areas of the New Territories. TSW's final stage was completed in early 2000. Since mid-2000, a chain of domestic violence drew public attention to the question of whether a self-reliant 'satellite town' is still relevant to contemporary urban planning. *The Way We Are* was made in response to such controversies over TSW. Kwai, a generous widowed mother, works and lives in TSW. One day, while passing through a shopping arcade near home, she runs into her new colleague, Leung, an independent elderly. Leung is selecting a TV set in an electrical appliance store. To help Leung to save the extra charges on the delivery service, Kwai calls her son, On, to carry the TV set to Leung's home. The rest of the movie sees Kwai and Leung's regular encounter in the same plaza. With these unplanned meetings, their friendship grows rapidly. However, the remoteness of TSW limits the daily activities of its residents to just a few locations. The relatively low mobility provides a condition for the development of more stable and permanent bonding among the people therein. Contrary to popular discourse circulating in the year of its release, *The Way We Are* shows TSW as a place filled with care and love instead of marred by senseless violence. ⟿*Lam Wai-keung*

Photos © Wong Fei-pang

Directed by Ann Hui (Hui On-wah)

Scene description: Kwai helps Leung as they meet inside an arcade
Timecode for scene: 0:34:51 – 0:36:46

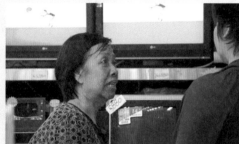
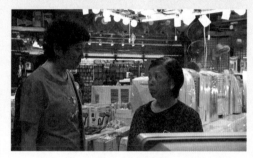

NON-PLACE, OTHER SPACE (2009)

Walled City in Kowloon City (1992) and the Victoria Harbour shore in the Western District now redeveloped

THIS IS A WORK of visual ethnography – of my walking through the city of Hong Kong, also a compilation of fragments of HK's urban space collected in my video diaries 1991–2008. Except for the high-rises captured from the mid-levels, almost all locations have disappeared from the map due to urban re-development. 'Walking through' is a precarious experience. One penetrates, dives into, or emerges from … One moment I see, therefore the camera records for me; in another moment the camera sees and retains, I then discover. Virtual sounds I barely grasp in my mind and fragments of a voice I have long forgotten all blend into the placeless other space of non-place. Places and lived moments of disappearance return as the in-between, neither monumental nor illusionary. The montage work throughout creates visual poetry that highlights individual images as autonomous fragments – a sufficient state to contribute to an open mnemonic system. A tree-sheltered entrance to a wall of cubicle-flats is the first shot made with my camera, but also the last I have, of the Walled City. A close-up shot of a denture in a shop-window asserts a dominant trade once flourishing within. The swollen corpse of a chicken points to Western District's wholesale activities. *Non-place, Other Space*'s nineteen-time appearance in sixteen cities – in festivals for short, experimental, documentary and ethnographic works – and in nine art-gallery shows exploring HK's city space – affirms the value of the work's persistence in preserving diminishing views of everyday life and its resistance against stereotype icons of HK. **⁖Linda Chiu-han Lai**

Photos © Wong Fei-pang

Directed by Linda Chiu-han Lai
Scene description: An ethnographer preserves views of the Walled City and Victoria Harbour
Timecode for scene: Various parts of the 14-minute run time

BIG BLUE LAKE (2011)

River in Ho Chung Village, Sai Kung, New Territories

SET IN SAI KUNG in the New Territories, the film tells the homecoming story of Cheung Lai-yee (Leila Kong) after her ten-year sojourn abroad and, through interviews with local village elders, presents the old and new faces of Ho Chung Village. The film shows tranquil mountain greenery and crystal-clear river water, with dragonflies hovering around young leafy water-grown plants that sashay in the wind. Amidst that scenery of nature, a local villager, Uncle Tim (Lau She-tim), narrates his happy childhood; his swims in the river catching fish and shrimps and picking fruit from the trees. The camera shifts to Lai-yee and her meeting with an old neighbour Siu-man (Joman Chiang) and her son. They walk along a grassy path along a river by a road with busy traffic. Lai-yee laments the many changes that have made her village unrecognizable – drainage work has turned the small river into an irrigation channel and, with property development along the coast, agricultural fields have been taken over by high-rises. Siu-man, in response, rejoices that with ongoing engineering works, the river no longer floods. She can now play with her son along the river even after the rain, and there is still a lot of fish in the river. Many new-generation villagers share her optimism – they are convinced nature is still close at hand. After all, changes are inevitable and perhaps not necessarily a bad thing – as is the case of Ho Chung, where the beauty of nature remains, especially compared to other areas of Hong Kong. ➙*Chu Kiu-wai*

Photo © Wong Fei-pang

Scene description: Nature in the city
Timecode for scene: 0:15:02 – 0:17:22

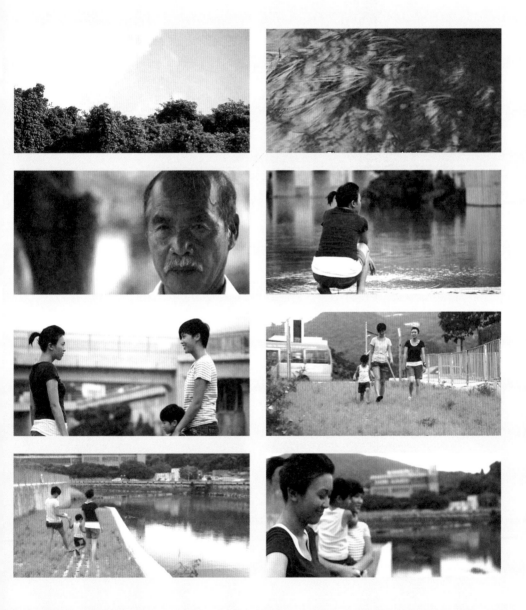

LIFE WITHOUT PRINCIPLE (2011)

Victoria Harbour, viewing from the promenade of Tsimshatsui on the Kowloon side

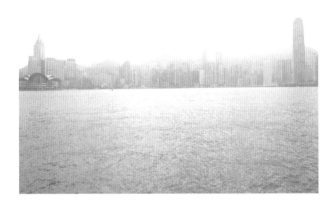

JOHNNIE TO'S *Life Without Principle* uncovers people's gradual loss of principles in a cash-driven society. Director To created the portraits of two types of 'others' in Hong Kong: the Chinese Mainland 'others' and the 'others' from foreign countries. The Victoria Harbour, which lies between Hong Kong Island and the Kowloon Peninsula, is used as a metaphorical scenic spot in presenting the relationship between HK and powerful foreign nations that control the world's economy. In the film, the harbour appears a few times as a four-second transition with no particular story content, forging an oppressive keynote: dark clouds shrouding, forecasting the coming of gloom and doom, hinting at the HK economy's over-dependence on foreign powers. The hinted gloom always immediately promises to be true in the next scene – anxious faces in the bank with another unanticipated plummeting of cash values caused by another collapse of a foreign financial institution or political instability somewhere in the world. The appearance of the harbour in the film also echoes the harbour's own history: a harbour in HK with its original name Hong Kong Harbour, it was later renamed after Queen Victoria and became a memorial landmark in Britain's colonial-overseas portfolio. Is this by sheer coincidence? The Chinese character for the sea, 'hai', often goes together with 'wai', which means outside, to form the idiomatic expression for 'overseas' – 'hai wai', thus the financial power of foreign 'others' which traps and regulates the pulse of HK society. **↝Sugar Bingji Xu**

Photo © Wong Fei-pang

Directed by Johnnie To (To Kei-fung)
Scene description: Empty shots of Victoria Harbour
Timecode for scene: 0:26:13 – 0:26:17

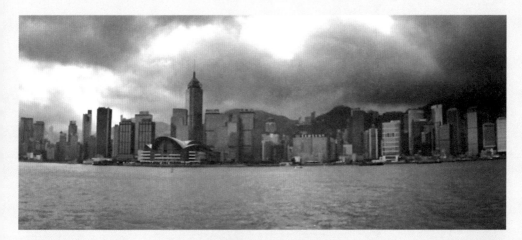

ON THE EDGE OF A FLOATING CITY, WE SING (2012)

Union Industrial Building, 116 Wai Yip Street, Ngautaukok, Kowloon

ON THE EDGE OF A FLOATING CITY, *We Sing* is an essay film about the notion and practice of freedom via spatial stories and vignette episodes on local indie music in Hong Kong. Organized in three parts, the work shows three different places picked by three musicians. Ah-P from *My Little Airport* chose Kwuntong/Ngautaukok where he had his studio. At the moment of shooting, he faced the chance of forced evacuation in a year with property market prices soaring. This scene starts inside the elevator of Union Industrial Building. As doors close and ambience rises, viewers read texts on-screen like reading a book. They learn of the government's 'revitalization policy' for industrial buildings, of how the policy further pushes up the rental of units in such buildings and, finally, of the Artist Factory Concern Group's suggestion to the government on how to help the creative industries. Information on-screen is interrupted visually, audibly or by silence, as the elevator doors open and close intermittently, showing the different views on the various floors: a closed office with paper signage, an office under renovation, a handmade-candies workshop and so on, finally taking us to where the musician's studio is. The static slow-motion long-take inside the elevator now becomes a steady-cam shot penetrating a narrow corridor until reaching Ah-P's studio. All along, the director's reflexive voice-over delivers her poetic reflection on the idea of home and the history of the Kwuntong district, which is also where the director was born and grew up.
⟿ Anson Hoi-shan Mak

Photos © Wong Fei-pang

Directed by Anson Mak (Mak Hoi-shan)
Scene description: Landscape from the elevator, Union Industrial Building, Ngautaukok
Timecode for scene: 0:06:15 – 0:13:50

政策表面上「質放」業主改變土地用途，
令社區更新，但事實上，只有大財團／
大業主才有能力收購全權素權，結果，
更便利了大發展商收購工廠，從中獲取
更大的利潤。原本分散的業權則愈來愈集中
在飛個大財團手上。令小業主更難以生存。
投機者也借進個政策的「氣氛」，進行
短線炒賣，令租金不合理地大幅飆升，
租戶無所適從。

香港政府在2010年實施「活化工廈」
政策，措施包括：1）15年樓齡的舊工廈全
體租客進行收樓，大業主付更改土地用途的
豁免費；2）改地契後補地價若超過2,000萬
元，業主可以足是分5年攤還（總地價的八
成）；3）政策容許「按實補價」，
工廈業主只須按重建後的新增密度補地價，
因非以土地最高發展密度計算；4）大業主
按《土地（為重新發展回強制售賣）條例》
強制拍賣（30年樓齡的）非工業區工廈，
門檻由九成業權降至八成。

The formerly dissipated interests are increasingly
dominated in the hands of a few corporations,

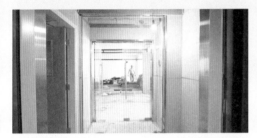

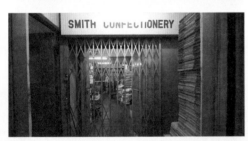

SMITH CONFECTIONERY

I don't know whether I really did,
or I just fantasized it too much that it gradually turned into a memory

WALKER (2012)

Mongkok's pedestrian zone on Sai Yeung Choi Street, Kowloon

WRAPPED IN A RED ROBE, Lee Kang-sheng carries a white plastic grocery bag in his left hand, and holds up a pineapple bun (typical local HK snack) with his right hand. Shaved with no hair and barefoot like a monk, Lee walks slowly in the busy streets of Mongkok. Each step is a serious step. His stroll is itself a contrast with Hong Kong's fast-paced urban life, and the director uses his slowness to give us a particular vision of the place. As we follow Lee's footsteps and occupy his haptic space, we also share his sense of time while immersing in fast-paced HK. The narrative body of the film is Lee's maneouvre, which visually sets up director Tsai's engagement of the audience: he drags us into the paradox of space and time, leaving us in a state of teeth-grinding delirium. Lee Kang-sheng strolls through Mongkok's pedestrian zone. As he softly penetrates, the swelling crowd around him disperses. Imagine him as Moses making his way through the Red Sea as water divides and subsides on his every stride. In Lee's perceptual space, we see the many colourful signs and notice Mongkok is actually full of reds and yellows. Night thickens, what is left is the empty Mongkok pedestrian flyover, still dazzling green, but now the playground for cleaning workers and Lee Kang-sheng. Tsai Ming-liang is a director from Taiwan, but the 'Hong Kong' on camera in this film is nothing we have seen from any other HK film-makers. **↝Rita Hui (Hui Nga-shu)** *(trans. Kimburley Choi and Linda Lai)*

Photo © Wong Fei-pang

Directed by Tsai Ming-liang
Scene description: *Lee Kang-sheng strolls leisurely in Mongkok*
Timecode for scene: *0:13:13 – 0:14:20*

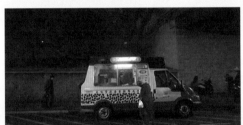

GO FURTHER

Recommended reading, useful websites and film availability

BOOKS

At Full Speed:
Hong Kong Cinema in a Borderless World
Ed. by Esther C. M. Yau
(University of Minnesota Press, 2001)

Between Home and World:
A Reader in Hong Kong Cinema
Ed. by Esther M. K. Cheung and
Chu Yiu-wai
(Oxford University Press, 2004)

Consuming Hong Kong
Ed. by Gordon Mathews and Lui Tai-lok
(HKU Press, 2001)

Hong Kong Cinema:
The Extra Dimensions
by Stephen Teo
(BFI, 1997)

Hong Kong Connections:
Transnational Imagination in Action Cinema
Ed. by Meaghan Morris, Li Siu Leung
and Stephen C. K. Chan
(Duke University Press, 2006)

Hong Kong:
Culture and the Politics of Disappearance
by Ackbar Abbas
(HKU Press, 1997)

Hong Kong Screenscapes:
From the New Wave to the Digital Frontier
Ed. by Gina Marchetti, Esther M.K. Cheung
and Tan See-kam
(HKU Press, 2011)

Invisible Cities
(Italian: **Le città invisibili (1972)**)
by Italo Calvino
(English translation, Mariner Books, 1978)
(original work, Giulio Einaudi Editore, 1972)

'On the Edge of Spaces: Blade Runner, Ghost
in the Shell, and Hong Kong's Cityscape'
by Wong Kin-yuen
Science Fiction Studies, #80, v27(1),
March 2000
http://www.depauw.edu/sfs/backissues/80/
wong80art.htm

Our Home, Shek Kip Mei, 1954–2006
By Vincent Yu
(Jian Yi Le, 2007)

Planet Hong Kong:
Popular Cinema and the Art of Entertainment
By David Bordwell
(PDF version. *http://www.davidbordwell.net/*
books/planethongkong.php)

街邊有檔大牌檔
[trans. hawkers' stalls by the street side]
莊玉惜
(Joint Publishing, Hong Kong, 2011)

ONLINE

David Bordwell's Website on Cinema
http://www.davidbordwell.net/blog/

Hong Kong Film Archive
http://www.lcsd.gov.hk/CE/CulturalService/
HKFA/en/home.php

Hong Kong Film Critics Society
http://www.filmcritics.org.hk/

Hong Kong Films' Web
http://www.hkfilms.com/Home.shtml

Film Culture Centre (Hong Kong)
http://www.hkfcc.org/

Hong Kong Cinemagic: Mapping Hong Kong
Film Locations
http://www.hkcinemagic.com/en/page.
asp?aid=326

Hong Kong (& Macau) Stuff
http://orientalsweetlips.wordpress.com/category/
film-locations/

CONTRIBUTORS

Editor and contributing writer biographies

EDITORS

LINDA CHIU-HAN LAI is Associate Professor in Critical Intermedia Arts at the City University of Hong Kong's School of Creative Media. After completing her Ph.D. in Cinema Studies at NYU, she has sought meaningful extension to other relevant artistic and theoretical endeavours. She is a historian, film scholar, artist, creative writer, and independent curator for contemporary and media arts. Her academic-artistic research focuses on visual/auto-ethnography, urbanity and archiving, and micro-meta narrativity in media art. An interdisciplinary artist, she explores research-creation approaches, upholding theory as practice. Her experimental videography, installation and visual ethnography have been presented in historians' workshops and shown in ethnographic, documentary and experimental short film festivals in over twenty cities around the world. Published academically on HK and Chinese cinema, her essays are rigorous experiments with historiography. She is also a writer on contemporary and new media art. She is founder of HK-based new media art group the Writing Machine Collective.

KIMBURLEY WING-YEE CHOI is Assistant Professor at the City University of Hong Kong, where she teaches cultural studies, visual ethnography, critical theory, and film history. The most impressive film for her is the old 3D *House of Wax* (André De Toth, 1953), which brought her a high fever after watching it as a repeat on a Cantonese TV channel with her mother at home when she was only six. Her research interests include consumer appropriation, audience reception, glocalization, and visual ethnography. She is currently conducting visual ethnographic research on the consumption of 'toys' and parent-kid relations in the new media age. She is the author of articles in *Cultural Studies Review*, *Social Semiotics* and *Urban Studies* and is the author of *Remade in Hong Kong: How Hong Kong People Use Hong Kong Disneyland* (LAP, 2010).

CONTRIBUTORS

Film scholar Michael Berry has called **EVANS CHAN** 'one of the most singularly innovative and diverse figures in the Chinese cultural world'. Born in Guangdong and raised in Hong Kong, Chan is a New York-based critic, playwright and film-maker. Over the last two decades, Chan has made four narrative features and seven documentaries, including *To Liv(e)* (1992), *Crossings* (1994), *The Map of Sex and Love* (2001), *Adeus Macau* (2000), *Journey to Beijing* (1998), *Sorceress of the New*

Piano (2004) and the most recent *Two or Three Things about Kang Youwei* (2012). *Time Out Hong Kong* (March 2012) has named Chan's *To Liv(e)* one of the 100 Greatest Hong Kong Films. His most recent docudrama *Datong: The Great Society* (2011) received the 2011 Chinese-language Movie of the Year from *Southern Metropolitan Daily* – a member of the media group, whose journalists went on strike in early 2013 to demand press freedom in the PRC.

DEREK CHIU (CHIU SUNG-KEE) is a Hong Kong-based film-maker. His directorial repertoire includes *Pink Bomb* (1992), *Mr. Sardine* (1994), *The Log* (1996), *Sealed with a Kiss* (1999), *Comeuppance* (2001), *Love Trilogy* (2003), *Brothers* (2007), *72 Martyrs* (2011) and *My Boy Friends* (2012), among others. Over the years, Chiu's films have won awards at the Chinese American Film Festival, Macau International Film Festival and Shanghai International Film Festival. He has also received Hong Kong Film Awards and Golden Bauhinia Awards. Many of Chiu's films screened in various international film festivals received critical acclaim, including at the Berlin International Film Festival, Hong Kong International Film Festival and Hawaii International Film Festival. Chiu is also Assistant Professor at the City University of Hong Kong, teaching directing, scriptwriting and TV production.

CHU KIU-WAI is a Ph.D. candidate in Comparative Literature at the University of Hong Kong. He received his previous degrees from SOAS, University of London and Cambridge University. He is currently a visiting Fulbright scholar in the English Department at the University of Idaho. His research focuses on contemporary Chinese cinema and art, comparative ecocriticism, and environmental thought in visual culture. His papers and writings on Chinese films and art can be found in *Neverthere: Images of Lost and Othered Children in Contemporary Cinema* (Debbie Olson and Andrew Scahill [eds], Lexington Books, 2012), *Modern Art Asia: Selected Papers Issue 1–8.* (Majella Munro [ed.], Enzo Arts and Publishing, 2012), *World Film Locations: Beijing* (John Berra and Liu Yang [eds], Intellect, 2012) and *Transnational Ecocinema* (Pietari Kääpä and Tommy Gustafsson [eds], Intellect, forthcoming May 2013)

BRYAN WAI-CHING CHUNG is an interactive media artist and design consultant. His interactive media artworks have been exhibited at the World Wide Video Festival, Multimedia Art Asia Pacific, Stuttgart Film →

CONTRIBUTORS

Winter Festival, Microwave International New Media Arts Festival and the China Media Art Festival. In the former Shanghai Expo 2010, he provided interactive media design consultancy to various industry leaders in Hong Kong and China. Chung studied computer science in HK, interactive multimedia in London, and software art in Melbourne. He also develops software libraries for the open source programming language Processing, initiated by the MIT Media Lab. His forthcoming book is *Multimedia Programming with Pure Data* (Packt Publishing, 2013). Currently, he is Assistant Professor in the Academy of Visual Arts, Hong Kong Baptist University, where he teaches subjects on interactive arts, computer graphics, and multimedia production. His personal website is: http://www.magicandlove.com.

STEVE FORE works in the School of Creative Media at the City University of Hong Kong, where he teaches in the areas of animation studies, culture and technology studies, 'new' and 'old' media theory and history, surveillance studies, and documentary media. His current research is concerned with the ways in which animation artists have negotiated a relationship with the ongoing technological transformations of their creative form. In addition, he has written extensively on HK and Chinese Cinema, including essays on Jackie Chan, Clara Law, and Chinese rock and roll movies.

HO YUE-JIN is a media artist, translator, writer and art critic. His works have been shown in Australia, China, Germany, Hong Kong and Japan, and selected by various festivals, including the Hong Kong Independent Short Film & Video Awards, ZEBRA Poetry Film Award Berlin and Shanghai Biennale. He received his MA in Photography and Urban Cultures from Goldsmiths College, London. He is now Assistant Lecturer for the Creative Writing and Film Arts Program at the Open University of Hong Kong.

RITA HUI (HUI NGA-SHU) is a film-maker, video artist and producer. Her works have been shown in various film and video festivals in Singapore, Thailand, Seoul, Japan, San Francisco, Paris, New York, London and Berlin. Her work *Ah Ming* (1996) gained wide attention and won the Distinguished Award af the Hong Kong Independent Short Film & Video Awards in 1996, and Work of Excellence at the Image Forum in Japan. In 1998, her works *She makes me wanna to die* (1998) and *Invisible City (Wall)* (1998) won the Sliver Award in the 'drama category' and 'alternative category' in the Hong Kong

Independent Short Film & Video Awards respectively. In 2009, she finished her first feature film, *Dead Slowly*, with funds from the Hong Kong Arts Development Council, which was shown in Pusan International Film Festival (PIFF) 2009's New Current section, and was the Opening film of the Hong Kong Asian Independent Film Festival, and nominated for best director at the 2009 Singapore Asian Festival of First Films. Her second feature film *Keening Woman* was completed in early 2013.

MIKE INGHAM has taught English Studies in the English Department at Lingnan University since 1999. Film, theatre, Hong Kong literature in English, and drama in education are Mike's areas of professional expertise. He is currently completing a study of HK documentary film for Edinburgh University Press together with Ian Aitken, and has published various pieces of critical writing on film, including a chapter on *Sorceress of the New Piano* in Hong Kong University Press' forthcoming book on Evans Chan's oeuvre. Mike's publications include *Hong Kong– A Cultural and Literary History* in the City of the Imagination series (Signal Books HKU Press, 2007) and *Johnnie To's PTU* in the New Hong Kong Cinema Series (HKU Press, 2009), 'Hong Kong's Dissident Documentarians' in *Studies in Documentary Film* (Intellect, 2012) and 'The true concord of well-tuned sounds: Musical adaptations of the sonnets' in BSA journal *Shakespeare* (Routledge, Taylor & Francis, 2012).

LAM WAI-KEUNG received his BA from the School of Creative Media, City University of Hong Kong. Upon completion of his undergraduate study, he joined the Federation of Hong Kong Filmmakers to liaise with film personnel to launch a series of professional training programmes for existing and emerging film-makers. Prompted by an interest in Cultural Studies, he completed an MA at the School of Humanities, University of Hong Kong. Currently, he is Acting Lecturer at the Hong Kong Design Institute. His teaching areas cover both theoretical and practical aspects: film studies, cultural studies and video post-production. *Solider Crab* (2004), a short film he directed, received the Special Mention Award at the 10th Hong Kong Independent Short Film & Video Awards.

ANSON HOI-SHAN MAK is a film, video and sound artist. She started writing, music and video works in the early 1990's. In recent years, she is interested in exploring experimental ethnography, research methods, and the novelty of the medium of super 8 film in the digital era. While experimenting further in moving images,

interactive digital archive and web-based platforms, she was inspired by phonography – the sound art of field recording. She has done a series of sound installation art projects titled 'Sonic Meditation' (2007-2009). Since 2006, she is interested in issues regarding spatial histories. At present, she works as Assistant Professor in the Academy of Visual Arts at the Hong Kong Baptist University.

MEAGHAN MORRIS is Professor of Gender and Cultural Studies at the University of Sydney and Distinguished Adjunct Professor at Lingnan University, Hong Kong. Her books include *Too Soon, Too Late: History in Popular Culture* (1998, Indiana University Press), *Hong Kong Connections: Transnational Imagination in Action Cinema* (co-edited with Siu-leung Li and Stephen Chan Ching-kiu, 2005, Duke University Press); *Identity Anecdotes: Translation and Media Culture* (2006, Sage) and *Creativity and Academic Activism: Instituting Cultural Studies* (co-edited with Mette Hjort, 2012, Duke University Press).

HECTOR RODRIGUEZ is a digital artist and theorist. His computational cinema piece *Gestus* (2012) received the Achievement Award from the Hong Kong Museum of Art (2012) and was a Jury Selection at the Japan Media Festival. His animation *Res Extensa* (2003) received the Best Digital Work award at the HK Art Biennial 2003 and has been shown in India, China, Poland, the US, Germany and Spain. He has recently exhibited in the Saatchi Gallery (London), the Athens Experimental Video/Media Festival, SIGGRAPH and other venues. He has published on film theory/history and digital art in *Screen*, *Cinema Journal*, and *Game Studies*, and participated in various art and technology conferences. Once Artistic Director of the Microwave International New Media Art Festival, where he taught workshops on Java programming and organized an exhibition on art and game, he is now a member of the Writing Machine Collective. He teaches game studies, generative and software art, contemporary/media art, and film theory at the School of Creative Media, City University of Hong Kong.

WONG AIN-LING is a film critic and researcher. She was the Head of Film Programming at the Hong Kong Arts Centre (1987–1990), Programmer of Asian Cinema at the Hong Kong International Film Festival (1991–1996) and Research Officer at the Hong Kong Film Archive (2001–2009). She is the author of *Xi Yuan* (Hong Kong Film Critics Society, 2000), and has edited various books on film for the Hong Kong Film Archive, including *Fei Mu: Poet Director* (1998), *Monographs of Hong Kong Film Veterans 2* (2001), *The Cathay Story* (2002), *The Shaw Screen: A Preliminary Story* (2003), *The Hong Kong-Guangdong Film Connection* (2005), *The Glorious Modernity of Kong Ngee* (2006) and *Zhu Shilin: A Filmmaker of His Times* (2009), among others.

Wong Fei-pang is an independent film-maker and video-maker. As a practitioner, he believes that film, like photography, is more than capturing beauty. He believes that photography implicates the relationship between the photographer and the subject, whereas film reflects the director's creative vision and ethical stance. Holding such views, his aim is to make movies that are true to themselves, to him and to others. While shooting the location shots for this book, he felt he was flipping through a history book of HK films. He recognizes that some movie locations still exist, some have been rebuilt, and some were demolished – and these changing landscapes parallel the changing spirit of HK cinema, that is, part of it sustains and part of it fades away. His video *The Death Dog* (2010) was granted Jury Recommendation at the 17th Hong Kong Independent Short Film & Video Awards.

SUGAR XU (XU BINGJI) grew up in Jiangsu Province, China. After earning her BA from the Foreign Language and Literature Department in Shantou University, she turned to studying media culture and received her MA from the City University of Hong Kong. As a non-local resident in Hong Kong, she has been amazed at how HK enlightens her and takes her steps closer to the world. With a great fancy for art and culture, Sugar explores continuously the possibilities between the world and herself. Currently she is working in the area of exhibition and art auction.

YIP KAI-CHUN received his BA and MA education in media arts and cultural studies respectively. He enjoys writing as much as art-making. He has also administered art projects such as the 2012 Microwave International New Media Arts Festival in Hong Kong. While a film-lover throughout, it was only in recent years that he started to appreciate HK cinema and discovered how different Hong Kong was. Yip has lived in Sham Shui Po, Hong Kong, since he was born. He loves Hong Kong.

FILMOGRAPHY

All films mentioned or featured in this book